Robert Hartle Jr.

...... THE

HIGHS & LOWS OF

LITTLE

★FIVE★

Robert Hartle Jr.

······ THE ······

HIGHS & LOWS OF

LITTLE

★FIVE★

A HISTORY OF LITTLE FIVE POINTS

Charleston London

THE
History
PRESS

Published by The History Press
Charleston, SC 29403
www.historypress.net

Cover design by Natasha Momberger

First published 2010

Manufactured in the United States

ISBN 978.1.59629.874.3

Library of Congress CIP data applied for.

For Erin, with all my love.

CONTENTS

ACKNOWLEDGEMENTS

Thank you Kelly Jordan, Don Bender, Dr. Richard Shapiro, Ira Katz, Harry DeMille, John Sweet, Jennifer MacDonald, Harlon Joye, Ann and Bob Hartle, Aunt Judy, Ben Wilson, Laura Collings, Mike Fishman, Barbara Joye, Reid Jenkins, Rebecca Birdwhistle, Ginger Lyon, Doug Paul, Julie Barker, Polly Price, Gail DeLoach, Van Hall, Martha Porter Hall, Dianne Brown, Patty Kunkle, Normando Ismay, Ebrima Ba, Lorraine Fontana and Scott Outman. Thanks also to Mary Anne Shamatta, Carol Bowers, Kelly Raines, the staff at the Special Collections Department and Archives, Georgia State University Library and the staff at the Georgia Department of Archives and History.

INTRODUCTION

Little Five Points is the most fascinating commercial area in Georgia, if not the entire Southeast. What makes it so remarkable is the fact that the overwhelming majority of stores in L5P are independently owned. Other areas of town have certain shops that, upon first look, appear to be independently owned mom and pop stores. Yet given a closer look, even these small, often charming boutiques, coffee shops or whatever they may be are corporately owned. Such is not the case in L5P, located two and a half miles east of downtown Atlanta; stores look like they are independently owned because they are. Unique stores owned by unique individuals draw the most eclectic mix of people found anywhere in Atlanta.

As L5P dentist Dr. Richard Shapiro said, "Little Five Points is the most tolerant place south of Greenwich Village and east of Haight-Ashbury. If you're not tolerated here, maybe you're just not tolerable." The tolerance that Shapiro speaks of has been tested recently but still allows flocks of homeless people, runaways and vagabonds to the area. The mix of these unique, independently owned stores and the cultural melting pot created by the tolerant environment is what makes Little Five Points such a popular destination for both locals and tourists. The revitalization of L5P, beginning in the 1960s, makes L5P's history some of the most fascinating and inspiring local history of the twentieth century.

The town of Edgewood, now called Candler Park, was incorporated into the city of Atlanta in 1908. Shortly thereafter, shops began opening between Candler Park and Atlanta's first residential neighborhood, Inman Park.

What ultimately emerged was known as Little Five Points, Atlanta's second commercial district after downtown's Five Points. The name Little Five Points originated from the five points that intersected at its center. Moreland Avenue provides two points, running perfectly north–south. Euclid Avenue provides another two points, running northeast–southwest. The fifth point, which no longer exists, was formed by Seminole Avenue, which met the intersection from the northwest before it was converted into Davis Plaza. The area thrived throughout the first half of the twentieth century and reached its peak in the 1950s. During this period, L5P was a typical shopping district with stores addressing the basic, everyday needs of their customers. I provide a brief summary of L5P up to the 1960s, but this book is not primarily a history of Little Five Points: it is, more precisely, a history of the revitalization of Little Five Points.

Little Five Points' heyday, in my opinion, began in the 1970s and continues today. The revitalization efforts to the area, which began to really take shape in the 1970s, exemplify true community development. The people involved were not your typical developers who clear out land for massive apartment complexes, large-scale subdivisions and colossal shopping malls. Rather, Little Five Points' developers were socially conscious, wide-eyed young men and women, influenced by the times and the opportunity to save an area decimated by "white flight" and the proposed Stone Mountain Tollway. It is important to keep in mind that the 1970s were a time in which social change was the spirit in the air. Also, these spirited redevelopers were in the right place at the right time and found their saving grace in the form of Mayor Maynard Jackson, who was elected under a new style of government in which the city council replaced the board of aldermen and the mayor became more of a leader and less of a figurehead. Mayor Jackson was a hands-on mayor, outspoken in his efforts to revitalize Little Five Points by providing grants, loans and an occasional persuasive phone call to stubborn property owners.

With a new, community action–oriented mayor, the organized and ambitious community in L5P was able to usher in a new era of small, independently owned businesses in a friendly, progressive atmosphere. As success mounted, the surrounding neighborhoods, specifically Inman Park and Candler Park, reemerged as well. Not that L5P is responsible for these neighborhoods' reemergence, but many of L5Ps redevelopers lived in these neighborhoods for which L5P was once the center of commerce.

During the 1980s and 1990s, the area experienced continued growth and success and established itself as an economic anomaly. Independently owned

stores continued to give way to corporate rule, and it seemed the only places where mom and pop stores still existed were hundreds of miles from the city limits. Occasionally an independent store would pop up in a shopping center, only to fold to a corporate buyout or takeover soon thereafter. Yet this small shopping district somehow managed to thrive with independently owned stores that offered goods as well as service that could not be found at corporately owned stores. Store owners like Ira Katz, owner of the L5P Pharmacy, developed personal relationships with their customers, who responded in turn with extreme loyalty. When the pharmaceutical giant Revco threatened to put Katz out of business, his customers rallied around him and let Revco know that it was not welcome in L5P. Residents of L5P as well as its surrounding neighborhoods were not about to open the door for a corporate takeover. They realized that if Revco moved nearby the L5P Pharmacy, a precedent would have been set. Soon, L5P would be just another shopping center. Revco realized that it was not worth the trouble to move into an area that would boycott it, and other corporations took notice. Though Starbucks and American Apparel, two major chain stores, are thriving in L5P, the overwhelming majority of L5P stores are independently owned.

L5P became the first Neighborhood Commercial District in the city, a designation that limits the size and shape of new businesses and the number of restaurants and boutiques that can open in the area. This makes it very difficult and often unappealing for corporations seeking to open up shop in the district. It also ensures that the area does not suffer the same fate as Buckhead. The stores in L5P are the most diverse in the Southeast and draw the most diverse mix of people in Atlanta. Nowhere else in Atlanta can claim the socioeconomic and cultural mix found in L5P. Soccer moms, punks, Rastafarians, vagabonds, hippies and white-collar families all share the same sidewalk on a daily basis, making the area the epitome of a cultural melting pot.

I vividly remember being about eight or nine years old and riding in the back of my mom's car, not believing what I saw: five green spikes, at least a foot tall, coming out of a guy's head. I wanted hair like that. When I got home, I raced into the bathroom with an ear-to-ear grin on my face. I stood in front of the mirror with a can of mousse and tried to duplicate what I had just seen. From that day on, I wanted to spend as much time as I could in Little Five. Luckily, my parents started going to church in the area. I would skip out on Sunday school and wander around Euclid Avenue.

The place fascinated me. I had never seen that many tattoos and piercings in my life; I had never been that close to a homeless man or what I thought

was a vampire. It was amazing. During my teens, I would come down for concerts at the Variety Playhouse or to browse through the shops. But it was not until I came back to Atlanta after five years of college in Dallas, Texas, that I really started to get what was so amazing about the area. It is not just an edgy part of town where parents don't want their kids hanging out or a place where people on society's fringe congregate—though this is an important aspect of L5P's uniqueness. What makes L5P unique is its independence and individualism.

There have been quite a few ups and downs in L5P's history, but ultimately the dedicated, passionate individuals who made L5P what it is today handled them with perseverance and foresight, creating the most unique commercial district in the Southeast.

I was able to interview many of these folks, and as a result, much of this book is transcribed from these interviews. I wanted them to tell the story of Little Five Points' revitalization so that my readers can hear it from the people who were actually there and who performed the amazing work to save the area from the many threats to its survival. I do not think that I would have been able to express the passion, dedication and incredible faith that they had in one another and the neighborhood as a whole without transcribing these firsthand accounts.

I did my best to include what I felt were the most important events, people and organizations within Little Five Points. I did not mention the fight over the Presidential Parkway. I focused solely on the original Tollway battle because the Presidential Parkway was a direct extension of the Stone Mountain Tollway. Furthermore, the fight against the Stone Mountain Tollway took place during the early revitalization years, which are the most interesting in L5P's history.

While researching and writing this book, I met so many wonderful people and heard so many fascinating stories that, even if this book were not published, it would have been worth the time and effort I put into writing it. That said, I thank you for buying this book, and I sincerely hope you enjoy it.

PRE-L5P/EARLY L5P

Where the Edgewood Retail District now stands was the site of the Battle of Atlanta on July 22, 1864. At the time, President Abraham Lincoln was on the verge of losing the support of the Northern people. He faced a critical election against Major General George B. McClellan, with the key issue being the war. The Northern people were losing patience for the war, which was costing far more money and lives than had been expected. The Battle of Atlanta was a must-win for Lincoln and the Union army since Atlanta was the main Confederate transportation and hospital center. General William Sherman's orders were clear: he was to score a victory so devastating to the Confederacy that the Union supporters would regain faith that the war was close to being won.[1]

Forty thousand men fought along 2.15 miles of land from the "modern intersection of DeKalb and Moreland Avenues to the vicinity of what is now Alonzo A. Crim High School on Memorial Drive, where the Battle of Atlanta began."[2] The men came from two Confederate corps and three Union corps. The Union corps prevailed, and approximately eighty-seven hundred men from both sides were killed, wounded or taken prisoner.[3]

When the war ended, some of the Confederates settled in what is now called Little Five Points. Colonel Asbury F. Moreland built his home on a large plot of land, which he named Moreland Park. An *Atlanta Constitution* article from 1886 announced that Professor C.M. Neal had purchased a large plot of land on Moreland Park for the purpose of erecting a military academy. The article lauded the beautiful park owned by Moreland:

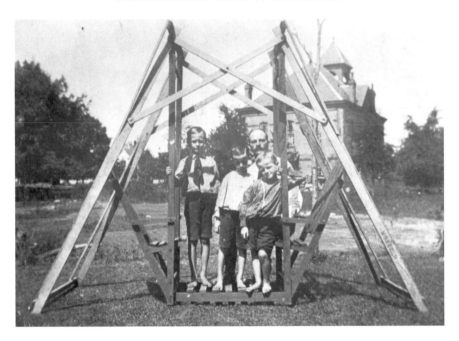

This 1906 picture shows Pierre M. Bealer in a double swing with three of his children, Pierre Jr., Carter and Louis. They are in the backyard of the Bealer home located in Little Five Points. Bealer was the manager of an A&P grocery store on Peachtree Street. *Courtesy of the Vanishing Georgia Collection, Georgia Department of Archives and History.*

> *Major A.F. Moreland, for whom the park derives its name, bought the property a number of years ago, and at once began to improve it. He enclosed it with a handsome fence, laid out many beautiful walks and drives, constructed a lake, a ten-pin alley, bathhouses and other accessories necessary to make a summer resort charming. Fairy land itself is not more charming than Moreland Park. Its twenty-seven acres, shaded with magnificent trees and carpeted with nature's green velvet, are the home of health and long life.[4]*

Neal opened the school after earning a distinguished reputation as the headmaster of Kirkwood Academy. The Moreland Park Military Academy was described as "a large and handsome brick building capable of accommodating 150 students. It will contain all necessary recitation rooms. In the second story will be a room large enough to seat 500 persons. The building will be two and a half stories high, its architecture to be the latest and most approved style. Its facilities for school purposes will be unexcelled by any similar institution in the south."[5]

One of Neal's star pupils was Willis Denny. Denny moved to Atlanta in the late 1880s to attend the Moreland Park Military Academy. After graduating from military school, he matriculated at Cornell. Denny returned to Atlanta in 1894 with a degree in architecture. Shortly thereafter, he married one of Moreland's daughters and began his career as a successful architect. One of his most impressive buildings was the home that he built for Victor Hugo Kreigshaber in 1901. The building still stands at 292 Moreland Avenue. It was scheduled for demolition in 1970, until a historic preservationist from New Orleans named Wilma Stone stepped in and bought the building, now known as the Wrecking Bar, and turned it into an antiques shop. Denny built several homes in and around L5P, some of which are still standing.

In what was an incredibly progressive move for the time, the Moreland Park Military Academy admitted girls at the request of Moreland, who wanted his daughters to receive an education. The highly touted Moreland Park Military Academy lasted only four years and, despite reaching its highest enrollment of 190 students in 1890, was reorganized and incorporated as the Georgia Military Institute. The original Georgia Military Institute (GMI) was located in Marietta but was burned when Sherman captured Atlanta. GMI changed locations frequently after moving into Neal's building, eventually becoming the Georgia Military Academy and then Woodward Academy in College Park. Neal allowed the Church of the Epiphany to use the main building as its meeting room after the GMI moved out. In 1903, when Neal's property was subdivided and auctioned off, a classroom building and dormitory were sold. Brooks Botanic Blood Balm Co. leased the property to manufacture its patent medicines until 1913.

In 1913, the Moreland School was created to alleviate the overcrowding of three nearby schools: the Edgewood Avenue School, the Highland Avenue School and the Inman Park School. The new Moreland School moved into the old Moreland Park Military Academy's campus. The *Atlanta Constitution* announced the opening: "The new school will greatly relieve the congested situation in this section of the city, which condition has been the greatest problem faced by the school authorities in the history of Atlanta."[6]

Mrs. Victor Kreigshaber and eighty-four other prominent ladies from Druid Hills and Inman Park met one late September afternoon in 1915 to examine the current school building. They found it to be far too small and outdated for their tastes and also complained that the building was unsanitary and unsafe for the children. Not surprisingly, the headmaster, Mrs. C.J. Maddox, agreed. A committee of ladies, headed by Mrs. Kreigshaber, explained its findings to the board of education.

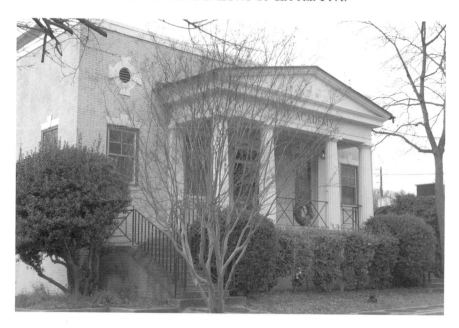

In 1986, Allison Mehtah and Curt Westley were able to preserve some of the Moreland Park Military Academy by turning its main building into office space. Mehtah and Westley remodeled the building, now called the Academy, at 368 Moreland Avenue, to resemble its original style by reclaiming the original walls, floors and ceilings, which had been covered by several layers of paint, plaster and tile. *Courtesy of Robert Hartle Sr.*

The school board agreed with the findings, and plans were readied for a new school building. The new Moreland School building was built at 1083 Austin Avenue and opened in late 1918. Roughly $40,000 was spent completing the new building, said to be one of the "finest and most artistic of the Atlanta schools" at the time.[7] The building is still an extremely important aspect of life in Little Five Points, serving as the home to the L5P Community Center. The community center houses such enterprises as the Euclid Arts Collective and WRFG radio station, and community meetings and fundraisers are held there as well.

The following excerpt is from a March 5, 1922 *Atlanta Constitution* article announcing a "new commercial block for Inman Park."

The rapidly developing business center of Inman Park's "five points"—at the junction of Euclid and Moreland avenues and McClendon and Cleburne streets—there has just been added [a] new business block. That such a block was in demand is evidenced by the fact that leases for four of the five store spaces have already been signed and a number of applications have been

made for the remaining space. The location of these stores is a particularly desirable one, being in the heart of Inman Park. The lay of the streets gave unusual freedom in the planning for the artistic as well as for the practical in a building.[8]

The article mentions Inman Park, but this new commercial block also served the town of Edgewood, now known as Candler Park. The first mention I found of Edgewood came from an 1871 *Atlanta Constitution* article announcing Edgewood property for sale.[9] Shortly thereafter, the town's first institution, the Edgewood Methodist Church, was formed. Edgewood was in its infancy then but developed substantially in the late nineteenth and early twentieth centuries. In May 1904, an advertisement with the heading "Great Edgewood Auction Sale" was circulated throughout the city of Atlanta. It advertised the auction of forty-six lots on Moreland and Euclid Avenues by H.L. Wilson—an example of the influx of families into the expanding neighborhood.

In July 1908, Alderman Quillian, chairman of a special committee on extending the limits of the city of Atlanta, announced that city limits would be extended to include the town of Edgewood, effective January 1, 1909. Two of Atlanta's first residential neighborhoods—Edgewood and Inman Park—were adjacent to each other, and the need for a shopping district was clear. Inman Park was growing rapidly, as was evident in an *Atlanta Constitution* real estate review from February 1909: "We consider this an unusually favorable time for buying choice residence lots, which as a rule, have not materially advanced in price, while building materials are cheaper than for years, and labor is abundant and cheap. It is conceded that such favorable conditions for home-building have not existed for a number of years."[10]

An equally important reason for the creation of this commercial district was the trolley line that ran through the area. Atlanta business mogul Joel Hurt created the Atlanta and Edgewood Street Railway Company, which opened in 1886 and ran along Edgewood Avenue. Atlanta's first electric streetcar line connected Inman Park with downtown Atlanta so that Inman Park residents could go downtown to shop. After Druid Hills was founded, in 1908, the streetcar line was extended past Inman Park into that area. Inman Park and Edgewood became not just a destination on the streetcar line but also a stop for many people on their way home to Druid Hills. Druid Hills residents made up a new market. It stands to reason that if a commercial center were created around Inman Park and Edgewood that served people's

everyday shopping needs, Druid Hills residents would shop there rather than make the trip downtown.

Businesses began sprouting up around the area, and by the early 1920s, L5P had become an established yet expanding commercial district. Ironically, when the Edgewood Retail District opened on Moreland Avenue, just south of L5P, in 2005, many people supported it because before it opened there had been no stores close by where they could shop for everyday goods. Yet in 1923, L5P was being praised in the *Atlanta Constitution* for how convenient and accessible shopping was:

> *One of the most active of the commercial centers in the outskirts of the city, for which Atlanta has gained much fame, is "Little Five Points." This handsome little commercial section, much like a miniature city, is made attractive by a number of splendid stores that have been established by some of the local merchants, several of the nationally known chain stores and other institutions necessary to its commercial completeness. The little community of merchants at "Little Five Points" seems prepared to furnish almost anything that a customer might call for…saving many trips to town and making it possible for residents to procure almost any article desired that formerly could only be gotten from the big stores in the heart of the city.*[11]

Nearly fifty commercial ventures were either underway or already established in L5P by September 1923.[12] The following is a list of businesses compiled by searching through advertisements from the *Atlanta Constitution* archives from 1923: Morris Tessler Grocery, 149 North Moreland Avenue; Buchanan-Floyd Grocery, 3 and 5 McLendon Avenue; Gulf Service Station on Euclid, Moreland and McLendon Avenues; Martin & Batte Druggists, 1 McLendon Avenue; King Hardware Store, 145 Moreland Avenue; Euclid Garage, 337 Euclid Avenue; Johnson's Dry Goods (clothing and apparel), 169–171 Moreland Avenue. There were quite a few more advertisements for other businesses, but they were in such poor condition that I could not make them out. Little Five Points was one of the most impressive and highly touted commercial districts within Atlanta because of the variety of goods its merchants offered as well as the proximity of its stores to one another.

There were also cafés and restaurants where one could get a drink. And, though not as regularly as today, folks would get in trouble with the law for public drunkenness. It was not just civilians getting in trouble with the law but police officers too. These are a few examples of L5P's finest boozing on the beat. In early September 1924, patrolman A.L. Kinard was arrested for

violating Prohibition laws and for drunkenness when he was found sleeping in a Little Five Points garage while on duty.[13] In June 1936, patrolman Paul DeFoor received a twenty-two-day suspension after he was found, off-duty but in uniform, blatantly intoxicated with three other officers at an L5P café.[14]

On the other end of the purity spectrum, L5P was home to a few churches, most notably the Church of the Epiphany. The cornerstone of the Church of the Epiphany was laid on March 17, 1898, at the intersection of Moreland and Euclid Avenues, where Findley Plaza now sits. Its structural design was "an early English type, built of stone and covered with shingles."[15] In a far more religious era, the church was responsible not only for worship but for entertainment as well, as is made clear in the following advertisement for "Epiphany Entertainment."

> *The Church of the Epiphany will give two entertainments at the parish house, corner of Moreland and Euclid Avenues, on Wednesday, June 16—one at 4 o'clock and one at 8 o'clock for the older children and their parents. The Rev. Cyprian P. Wilcox, rector of St. James' church, Cedartown, who has a fine reputation as an entertainer, will amuse both the young and old with stories, and a large assortment of clever tricks. He is also a ventriloquist of note.*[16]

The parish moved from the intersection of Moreland and Euclid Avenues to the intersection of Sinclair and Clebourne Avenues in 1923. Upon moving, the Church of the Epiphany established an Episcopal Mission in its new building, which cost a whopping $15,000 to build. A parish school was also established, and the parish house served as a community center for the Inman Park neighborhood.[17]

No Atlanta neighborhood could be complete, at the time, without a Baptist church. The first service held at the Inman Park Baptist Church occurred on May 26, 1895. The church had been renamed from the East Atlanta Baptist, and the building was located on Edgewood Avenue at the corner of Waddell.[18] Anyone familiar with Baptist preachers knows that they are a fiery lot. Inman Park Baptist's preacher, Reverend C.N. Donaldson, was no exception. He made headlines throughout the Southeast when he entered into a shouting match with the Reverend Charles W. Daniels in early January 1911. The argument took place at a meeting of Baptist ministers over whether reporters should be excluded from their weekly meetings, as well as over a proposed invitation to Dr. John Clifford, president of the World's Baptist Alliance. Clifford, an Englishman, had earned the scorn

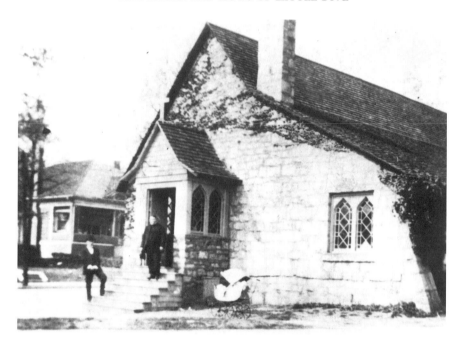

The Church of the Epiphany at the intersection of Moreland and Euclid Avenues in 1914. Standing at the door is the church's longtime reverend, Russell Kane Smith. *Picture taken by E.W. Mundy. Courtesy of Kelly Jordan.*

of Donaldson for questioning Biblical miracles. Donaldson emphatically exclaimed that "any man, no matter how prominent he be, who questions the miracles of the book, or the mystical element in the Christian religion, is not worthy of the name Baptist." Daniels was in favor of Clifford speaking at one of these weekly meetings and proposed the idea of expelling the Inman Park preacher from speaking at them. Donaldson angrily retorted, "I protest against personal matters being drawn into this discussion!" "You shut up!" exclaimed Daniels. "I'll do nothing of the sort, and I defy you to shut me up!" replied Donaldson. Both ministers rose to their feet as if a blow was about to be thrown. "You have no right to make these personal flings at me," yelled Donaldson. "I am a man, sir, and a born gentleman, and wasn't raised under any such a regime as Texas!" Donaldson was taking a personal shot at Daniels, who was raised in Texas. By this time, other ministers had stepped in and stopped the threat of violence.[19]

The purpose of including this little colloquy is to show how big a role the church played in everyday life at the time, even in Little Five Points. Today, a trifle between pastors is hardly front-page news, but in the early twentieth century, most aspects of life for most people centered on the church. There

was even a Little Five Points Baptist Church at 1240 Euclid Avenue from Easter Sunday 1930 to November 1932, when the Euclid Avenue Baptist Church bought it.[20] The church at 1240 Euclid Avenue eventually became home to the Atlanta Children's Coalition of Cornerstone Missions, which assisted the homeless, addicts and children from broken homes. As a result, the Children's Coalition had a volatile relationship with the neighborhood, according to one employee. In 2007, Jericho Partners bought the building from the coalition for $1.3 million. Its initial plan was to demolish the building and construct a parking deck surrounded by residences and storefronts along the street. Not surprisingly, neighbors opposed the plan. As a result, Jericho Partners leased the building to the Vision Church of Atlanta in June 2007 and began formulating a new plan for its recently purchased property. After a year of discussion and compromise between Jericho Partners and the Candler Park Neighborhood Association, a preliminary agreement was reached that would allow for the developers to build eight to ten condos within the church building and an additional thirteen town homes around it.[21]

Despite the Great Depression, Little Five Points continued to thrive. Almost immune from the financial panic sweeping the nation, L5P went on as if it were separate from the rest of the country. Businesses continued to open and subsequently prosper. The Palace Theatre is one example. The first mention of the Palace Theatre comes from a September 4, 1924 movie listing within the *Atlanta Constitution*. It advertised a film called *The French Doll*, starring Mae Murray. By October of that year, movies were showing every night at the new theatre on the corner of Moreland and Euclid Avenues. What is quite interesting about the Palace is the number of movies shown per week. For example, the Palace rang in the New Year in January 1925 with the following shows: the film adaptation of H.B. Somerville's historical novel *Ashes of Vengeance*, playing Monday and all day Tuesday; *Michael O'Flattoran* on Wednesday; *The Bedroom Window* on Thursday and Friday; and *Kentucky Days* to close out the weekend.[22] The Palace continued showing multiple films per week in an era when most theatres were changing films on a less frequent basis.

The year 1927 was a banner one for Little Five Points as an up-and-coming commercial center. An *Atlanta Journal-Constitution* article announced in May of that year that L5P was now a "lively business center." This article pointed out the success of Adamson-Coster Co., a well-known dry cleaning firm that had recently opened. More importantly, the article announced the opening of White Way streetlighting system. Leonard T. Cottongim, owner of Cottongim's seed store, and H.M. Bursom, owner of the Little

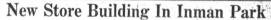

RST'S SUNDAY AMERICAN—A Newspaper For People Who Think—ATLANTA, AUGUST 27, 1922

nd Leases, And Building Activity (

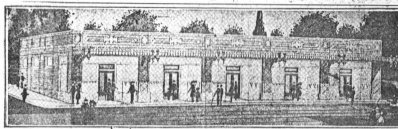

New Store Building In Inman Park

Real Estate Biographies

The property at 170 Peachtree Street, the sale of which at $144,000 was announced Friday, was first sold as a city lot in 1886 for $3000. At that time the owner, John H. James, made a good trade, for in 1861 he had bought the entire block, bounded by Peachtree and Forsyth Streets, Carnegie Way and Ellis Street for $$100, clearing $900 and a warranty deed to the remainder of the block by his sale in 1880.

The sale of the property constitutes one of the best real estate biographies yet printed. The enhancement from 1861 to date is shown in the following transfers compiled by the Atlanta Title & Trust Company:

Entire block bought by John H. James, and on May 15, 1880, he sold 170 Peachtree Street, 25x70, to R. A. Hemphill for $3000. Mr. Hemphill immediately resold the lot to W. A. Hemphill for $3500.

Mr. Hemphill sold it to Peter F. Smith, on February 14, 1901, for $7750. On July 2, 1902, Mr. Smith sold it to Walker P. Inman for $14,250.

The Saunders Loan & Investment Company acquired the property from the Inman estate on September 29, 1908, for $25,000, and resold it on February 13, 1920, to Martin and Harry May for $105,000. The Mays resold it yesterday to Dr. W. L. Champion for $144,000.

Since 1908 the property has enhanced $119,000, or at the rate of $8500 a year, exclusive of the rental on the present building during that period.

Ask Alteration
Bid On Miller

The growth of community business centers in Atlanta is strikingly shown in the above illustrations, the two pictures showing a before and after effect in Inman Park.

The residences are at the corner of Euclid and Colquitt Avenues. They are owned by George T. Smith, who is having them turned around at a cost of about $30,000.

The stores will be finished in cream brick, with terra cotta trim,

plate glass and marble under the showcases. A marquise will extend the full length of the front.

The stores are on the edge of one of the largest community centers in Atlanta—formed by the intersection of Moreland, Cleburne, Euclid and McLendon Avenues. This property was formerly the Colquitt home place. It was subdivided into lots and residences erected 14 years ago, and now they are giving way to stores.

Where the Church of the Epiphany recently stood in the triangle, bounded by Moreland, Euclid and McLendon Avenues, there is now a filling station. A branch of the Carnegie Library, of the Fourth National Bank and a dry goods store are the latest additions.

The store building was designed by Daniel & Beutell, the architects. J. H. Ewing & Sons are the renting agents.

$125,000 SALES ARE ANNOUNCED

REAL ESTATE AND BUILDING

Sale Of Property At 170 Peachtree Stree

This article is from a now defunct newspaper called *Hearst's Sunday American*. Dated August 27, 1922, it shows a sketch of a new store building with five storefronts at the corner of Euclid and Colquitt Avenues. In order for this building to be built, George T. Smith had to turn around the two residences (shown below the sketch) to make room for the building, which cost an estimated $30,000. *Courtesy of Van Hall.*

Five Points Shoe Shop, were two of the most outspoken supporters of this new streetlighting system, which ran throughout L5P on Moreland, Euclid, McLendon and Cleburne Avenues. White Way's opening was an all-out celebration in L5P. "Establishment of the 'White Way' will place this business and residential community as one of Atlanta's foremost commercial

centers and will mark an epoch in the rapid growth of the district," said one journalist. Mayor I.N. Ragsdale did the inaugural honors of flipping the switch that intensely illuminated L5P at 6:00 p.m. on the evening of May 30, 1927. The Atlanta Police Department band provided music for the inaugural celebration, and four speakers, including the chief of police and the chief of construction, elaborated on the importance of the new streetlighting system to an enthusiastic crowd.

In 1937, business was so good and there was such potential for growth that a civic organization was formed to promote "the upbuilding of the section in population, commerce, and finance; in civic and social improvement; in dissemination of information for the benefit of its members, and good fellowship of its members." The first meeting of the new organization, composed of more than seventy-five business and civic leaders, took place on November 22, 1937, at the Joseph C. Greenfield Masonic Temple on Moreland Avenue. John Powell was elected president of the new Little Five Points Civic Association, composed of both men and women "of good standing who are interested in the commercial, industrial and civic improvement of this section of Atlanta." Membership dues were fixed at three dollars per year. Bylaws were created, providing for eleven different

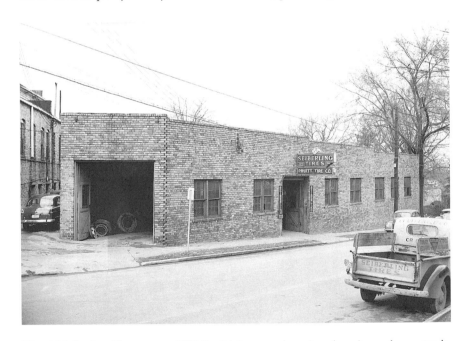

The old Seiberling Tires store at 1200 Euclid Avenue, where American Apparel now stands. *Courtesy of the Special Collections Department and Archives, Georgia State University Library.*

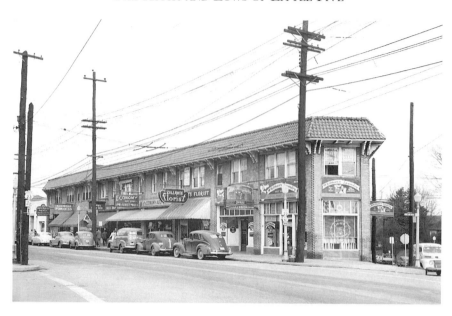

This picture, taken in the 1950s, shows the Point Center building, which Kelly Jordan bought in early 1977. In the 1950s, the Georgia Power Co. had a storefront in the Point Center building, as did Zillah's Florist and Economy Auto Stores. *Courtesy of the Special Collections Department and Archives, Georgia State University Library.*

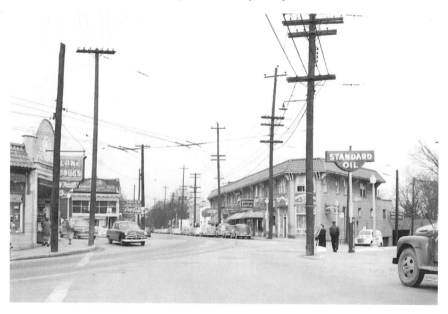

Standard Oil and Lane Drugs occupied the space now held by the Brewhouse Café and the Corner Tavern. Another photo likely from the 1950s, this was taken when Seminole Avenue connected with Moreland before being bricked over to make Davis Plaza. *Courtesy of the Special Collections Department and Archives, Georgia State University Library*

committees, including improvements; electric railways; lights and telephone; sanitary and health; legislative; police and fire; school; membership; publicity; finance; and entertainment.[23] The civic association was the group that residents would go to when something was needed in the area. Immediately, the civic association went to work addressing the need for a library in L5P, and in the 1940s, a library was opened. Little Five Points reached its peak in the 1950s and at one point was home to three grocery stores (Kroger, Colonial and A&P), four drugstores, three barbershops and three movie theatres (the Palace, the Euclid and the Little Five Points).[24] Yet L5P's luck was about to run out in the 1960s when two things happened that nearly permanently destroyed the area: "white flight" and the proposed Stone Mountain Tollway.

It is important to realize that, for its first sixty-odd years, Little Five Points was an ordinary place. There is a very limited amount of research available on L5P during this time precisely because it was so ordinary. This is not to say that there were not some interesting things going on in the neighborhood, but rather that when one compares it to other primarily commercial districts there is nothing that really stands out. Only when the revitalization of L5P began—after white flight and the cessation of plans for the Stone Mountain Tollway—did L5P become the fascinating example of individualism that it is today.

White Flight and the Stone Mountain Tollway

One extremely interesting facet of Atlanta's history is what is now referred to as white flight. I obtained the video of a talk that Kevin Kruse—author of the book *White Flight: Atlanta and the Making of Modern Conservatism*—gave at Emory University on November 3, 2005. Kruse reflects on the praise given to Atlanta during the civil rights movement for its progressive action toward desegregation, especially in the Deep South, where most cities were fighting tooth and nail against desegregation. National magazines and newspapers, and even President Kennedy, lauded Atlanta for proudly and peacefully desegregating its high schools and dubbed Atlanta the "Leader of the New South."

Yet Kruse asserts, in so many words, that the segregationists in Atlanta were simply ahead of the curve from those still fighting segregation. Atlanta's segregationists realized that fighting for segregation in public places was a battle that could not be won. "While their counterparts in

the deep south were clinging to a failing program of mass resistance," Kruse says, "segregationists in moderate urban centers like Atlanta found themselves forced to articulate a new defense of old white supremacy—less on the denial of civil rights for blacks, and more on the defense of their own rights." These rights that the neo-segregationists were fighting for included the right to select their neighbors, the right to select their employees and the right to select their classmates.

Kruse believes that these people saw desegregation as the federal government's intruding on their individual rights. The question that many

Above: This picture from the early 1970s shows the dismal shape the area was in. Cracked sidewalks and falling guard poles surround empty parking lots off Moreland Avenue. *Courtesy of Kelly Jordan.*

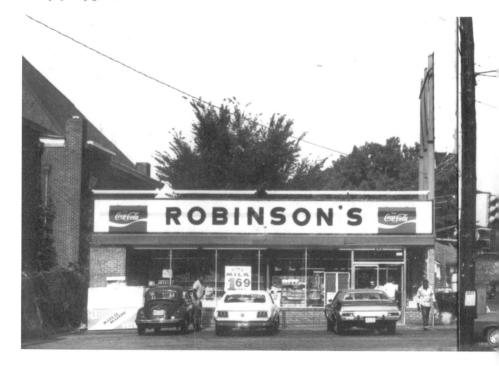

whites were asking at the time was, "If we are no longer allowed to decide whom we live next to, then how long until we are no longer allowed to decide who we are allowed to visit; or who visits us?" In other words, they wanted blacks to be able to enjoy their own freedom but not at the expense of the freedom of whites. Freedom of association was the rallying cry for these segregationists as August 1961, the start of desegregating Atlanta schools, loomed on the horizon.

For the first few years after 1961, the Atlanta school boards generally placated white parents and their children. It was quite easy for white students to remain

Below: Where the Chevron gas station now stands was once the home of Robinson's grocery store, next door to a large pawnshop. The storefronts on the other side of Euclid Avenue are unoccupied. Empty storefronts were the norm in L5P in the early 1970s. *Courtesy of Kelly Jordan.*

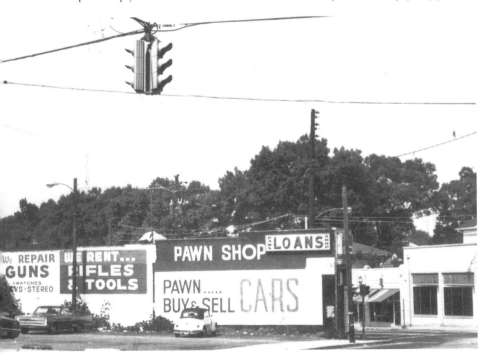

in their school if it was overwhelmingly white, and if white students were in a school that became too integrated for them it was easy for them to transfer to another school. However, if a black student wanted to transfer, the student would have to overcome a series of bureaucratic hurdles in order to do so. This lasted until early 1964, when the federal courts pressured the Atlanta Board of Education to expedite desegregation before the upcoming school year. In 1963, there were just over eighty transfers granted to black students; in 1964, there were over seven hundred. West Fulton High School had just 2 black students in 1962. In 1963, it had only 9. In 1964, after "token desegregation" gave way to the real thing, the student body of over 1,200 students was predominantly black. Over the first week of classes, white enrollment plummeted from 607 students to 143 students. According to one writer, "Bass High School [in L5P], which drew students from both sides of the railroad tracks along DeKalb Avenue, was the only high school in Atlanta with a natural balance of black and white students from its own district." She also notes that the whites remaining in Inman Park were only there because they didn't have the financial means to leave. "Inman Park itself was an economically depressed neighborhood of mostly blue collar white folks, elderly couples who could not afford to move, and families on disability and welfare."[25]

White families of means realized that they would have to pursue new avenues to maintain their freedom of association, and sending their children to private schools became the most attractive option. Those families who could not afford private schooling yet wanted "freedom of association" decided that their only alternative was to abandon the public school system. By 1970, white enrollment in Atlanta public schools was half what it had been in 1963. White families had undergone "suburban secessionism," moving out of the city altogether. Over the course of the 1970s, more than 100,000 whites left Atlanta—nearly half the city's white population. During this time, counties like Cobb and Gwinnett experienced a massive increase in white population. In 1970, they were 96 and 95 percent white, respectively. "Whites found them to be an ideal location for maintaining the goals of racial separatism that many of them had sought for so long," claims Kruse. Suburbs like Alpharetta and Cumming are more recent examples of white flight, which is not a thing of the past.[26]

White flight hit in-town residential neighborhoods like Inman Park and Candler Park hard and, in turn, sucked the cash flow out of Little Five Points. This, in combination with the proposed Stone Mountain Tollway, nearly spelled the end for the once thriving commercial district of L5P. The Tollway was a direct consequence of white flight. The Department

of Transportation envisioned two roads; I-485 would run north and south through the east side of Atlanta. The other, the proposed Stone Mountain Tollway, would run east from downtown to Stone Mountain. These two roads were proposed in order to provide easy transportation into downtown Atlanta for the white affluent families who had fled the city for the suburbs.

The Tollway Threat

In 1961, the DOT began buying up hundreds of acres of land for the two proposed roads. If these roads were built, the surviving parts of Little Five Points, Inman Park, Candler Park, Lake Claire and Poncey-Highland would be lit twenty-four hours a day by highway lights. Some of the proposed tollway would be elevated up to twenty feet in the air. Residents would be overwhelmed with constant automobile noise and smog.

Meanwhile, life in the "hippie district" in Midtown, particularly Fourteenth Street, was becoming a drag. Because they did not own any property, the hippies were getting dispossessed on the Fourteenth Street strip and were looking for new places to live. L5P residents such as John Sweet saw this as an opportunity to build up the community with like-minded people in order to fight the Tollway and the segregation that was occurring as a result of white flight.

I met with Sweet for lunch at his home. Talking with the energetic, passionate attorney was by far the easiest interview I have ever done. I asked him one simple question: "Could you tell me about your involvement with the Tollway and the neighborhood as a whole?" So he told me, over a bowl of chicken soup, the story of how he became a vehement opponent of the Tollway and an instrumental figure in redeveloping L5P. This is what I took from the interview, though Sweet is the type to give others credit and downplay the immense significance he had in L5P's success.

Sweet moved to Atlanta in 1968 after losing his Vietnam War deferment as a graduate student. After choosing VISTA (Volunteers in Service to America) as his alternative service, he was sent to Atlanta. He was set up in an EOA (Economic Opportunity Atlanta) office at the intersection of Memorial Avenue and Boulevard and, after being stabbed, decided that he wanted a safer place to spend his nights when finished with work. "I wanted to have a place to live in at night which wasn't as stressful as where I worked during the day, so I got permission to move into this neighborhood [L5P], which was a poverty-impacted neighborhood," said Sweet. "I stayed

for two years to do my alternative service and then, because I lost my rent-controlled apartment in Manhattan and because the grad school I was going to wouldn't allow people to come back if they were away from their PhD for two years, I decided to stay here." Sweet was also quite poor at the time and, as a result, found L5P a much easier place to live than New York City.

He was well aware of the dangers that the proposed Tollway brought to the neighborhood and went to work recruiting the displaced hippies, formerly of Fourteenth Street. "We had a new mantra," Sweet said. "The new mantra was 'buy the place you're in. Don't let the Fourteenth Street thing happen again.' One of the interesting things about L5P at the time was that we were trying to invent new forms of land tenure for the hippies. They had said things to me like, 'I don't want to get tied down. I want to be able to throw all my stuff in a suitcase and head to San Francisco tomorrow if I feel like it.'"

The more people who moved into L5P, the better, since, as Sweet asserts, the City of Atlanta had planned a barrier in the 1950s that encouraged white flight, and L5P was right in the middle. "There was a barrier, planned by the city fathers, using Ponce de Leon Avenue on the north and North Avenue on the south, running from downtown out toward Decatur. The idea was to tear down all the residences [between Ponce and North Avenue] and the white people would live on the north and the black people would live on the south." This plan predated the Tollway and shows that the city had planned to get rid of L5P for quite some time. The only way to stop the destruction of the area was to attract people who were willing to fight the Tollway.

Since the 1950s, businesses as well other institutions in the area had been folding left and right. All of the churches in the neighborhood had lost their congregations, and the ministers' efforts to sell the churches were fruitless. Therefore, they began selling the churches to the highway department, which would buy them and tear them down. Pastor Charlie Helms sold the Inman Park Presbyterian Church and, rather than taking the money and leaving the neighborhood, used the funds from the sale to start UTOA (Urban Training of Atlanta), a foundation aimed at stopping the Tollway. Helms was hired as a pastoral minister to L5P and literally walked the streets organizing support against the Tollway. Sweet recalled:

At the same time the Mennonites had gone to the government and said, "We would like to do alternative service." Instead of going through VISTA, they were sent on what were called Mennonite Projects. By the time I moved here the Mennonite Project was over in the old Fourth Ward by David T. Howard High School. Very shortly thereafter, they moved into Little

Five Points and started what's called a Mennonite House. So you had the Mennonites and the EOA set up a community congress, which would meet on a weekly basis. It was made up of Little Five Points, Inman Park, Poncey-Highlands, Lake Claire and Candler Park. These meetings would last all day—at least eight hours—and the neighborhoods would report on what they were doing and we'd talk about general issues; but it was really a massive forum for organizing against the highway.

At this point, opponents of the Stone Mountain Tollway knew that they were losing the battle and were getting desperate. "There were some signs that we were beginning to have the tactics of people who were losing. When you're winning you have certain tactics and when you start to lose you start doing things that are a little more desperate," Sweet explained. Sweet was ready to shift into desperation mode but was not excited about doing so. "And then one day, without me doing anything about it, Danny Feig [now Danny Feig-Sandoval] went down to the construction site [on the land where the Presidential Library now stands] and sat down on an I-beam. They told him to get off the I-beam and he said, 'No,' and they arrested him. The next day he came down with five people and they arrested all of them. When that happened it was incandescent. BOOM! It went right through the neighborhood."

By this point, Sweet's legal career was blossoming, and he had an office downtown, right next to the jail. One day, he received a call saying that all hell had broken loose.

They told me that the arrests were paramount and would I do something about it. I said, "Sure, send them up to my office and I'll get them lawyers." So I shut my office down and went into the atrium. First 3 people come in and say, "We've been arrested for criminal trespass." I said, "Okay," and I got my Rolodex and I called Richard Johnson, an attorney who I taught when I did some teaching at Emory. I told him, "I've got 150 people here who've been arrested in a mass protest and I need you to represent them for free."

Johnson agreed, even before Sweet made it clear that Johnson would only have to represent 3 protestors and not the entire 150. Sweet continued to flip through his Rolodex and call in favors from other attorneys until all of the protestors were represented. "I sat there all day long," he said. "The next day was the arraignment and the judge asked, 'Who's here representing the people arrested at the highway?' and 33 volunteer lawyers stood up. We had black lawyers and white lawyers, which was very, very important. A guy named

Raines Carter, the chief solicitor, came over to me and said, 'Look, I'm not going to fight 33 lawyers. This is all over; I'm kicking all of these cases out.'"

After this massive victory, the few people in the neighborhood who were ambivalent about the highway quickly turned oppositionists. "We were all poor. This wasn't, at the time, a wealthy neighborhood. But every block—not street, but block—had a captain and that captain was expected to host a fundraising party every year on his or her block. You were expected to bring at least $100 so every block raised about $1,200 every year."[27] Every penny raised from these fundraising parties went toward fighting the Tollway. While other neighborhoods that were opposed to the Tollway were economically stronger, the level of discipline and consensus opposition to the Tollway in L5P made it pretty hard for anyone wanting to build a road through it.

The only folks in L5P who were for the Tollway being built were the old businessmen who had grown tired of weathering the storm created by white flight. The Little Five Points Businessmen's Association was composed mostly of older men who saw the Tollway as their big payday. For years, they had looked on as families had fled the neighborhood for the suburbs and taken their business with them. Signs were displayed in the windows of nearly every shop that read, "Highways are the lifeline of our economy." With L5P sitting off an exit on a major highway, customers from all over the state would be coming in; and if one wanted to sell one's property, now was the time, since the DOT was buying up property to make room for the Tollway. It looked to the business owners like their prayers had been answered. Unfortunately for them—but to the joy of the young, motivated, urban pioneers in L5P who fought so tirelessly against the proposed road—Governor Jimmy Carter issued an indefinite postponement of the Tollway in December 1972.

Atlanta's most prolific underground newspaper, the *Great Speckled Bird*, rejoiced at the news and described the damage done to L5P as a result of preparations for the Tollway: "We joyously reiterate that the proposed Stone Mountain Tollway will not be built…For some time now the people living along or next to the proposed route have had eye-sore lots or over-run semi-jungles next door or behind their houses—not the most pleasant sight, as they tend to pile up with trash and garbage. The biggest shame is that this land has been sitting there, for years, being used for nothing."[28] The *Bird* also brought light to the fact that many retired, elderly people had been required to vacate their homes and were offered little in the way of compensation. The Tollway was being pushed for by the Department of Transportation but had been bogged down by numerous lawsuits.

REVITALIZATION

Neighborhood BONDing

Thankfully, while the Tollway was still a very real threat to the neighborhood, a group called the Bass Organization for Neighborhood Development (BOND) and other organizations committed to revitalizing Little Five Points were formed. Without the dedicated folks who made up these groups, L5P could not have reemerged as it did.

During my initial research, I came across two names synonymous with Little Five Points' revitalization: Don Bender and Kelly Jordan. I met with Don Bender on Halloween 2009 and spent some time with him talking about, among other things, the Stone Mountain Tollway. Bender comes off as serious yet friendly at the same time. He is a stoic with a gentle, kind voice who shows a genuine interest in making things around him better. Bender was raised in the Mennonite faith but became a Quaker in his early twenties.

"The transition from Mennonite to Quaker doesn't seem that big to someone looking on, but for me being a Quaker leaves much more room for free thinking," he explained. After being drafted during the Vietnam War, despite registering as a conscientious objector, Bender moved to Atlanta to perform alternative service, working as a teacher in the inner city. Along with his wife, Judy, Bender moved into a Quaker House on the outskirts of L5P in 1970. They immediately became attracted to the area and moved into a small home on Miller Avenue in 1972. Don became involved with the L5P community, and the biggest threat facing the neighborhood at that time was the Tollway. Bender remembers this time well.

In 1972, Jimmy Carter appointed an eight-member blue ribbon panel composed of four people he assumed were somewhat opposed and four people he assumed were somewhat supportive, and asked them to make a recommendation. We had hearings for those opposed where literally thousands of people showed up and lasted early into the morning. I went to these to speak but I never got a chance because I knew I had to work the next day and I would never get home in time if I stayed. Then they had the hearings for the people who were for the road and just a handful of people would show up and so the recommendation came out eight to zero against the road.[29]

Kelly Jordan is quite the opposite of Bender in demeanor. He is lively and often humorous when he talks about the revitalization of L5P, often mimicking people with whom he interacted. He is also quite humble. Though he makes business deals involving hundreds of thousands of dollars, he is not in it for the money. Many people say, "I'm not in it for the money" from the front porch of their million-dollar mansions, but Jordan is different. He lives in the same modest home in L5P that he has lived in for over thirty years, watches an ancient TV and drives a hybrid. He made the choice long ago that he would rather preserve the places that are dear to him than move away.

BOND, Kelly Jordan told me, was "made up of musicians and Quakers and wide-eyed radicals."[30] Jordan gave me access to a treasure-trove of old BOND records that he had saved over the years. BOND took on the revitalization efforts of five neighborhoods: Inman Park, Poncey-Highlands, Candler Park, Lake Claire and Little Five Points. It was already successful in collaborating with other organizations and institutions in "presenting environmental, social, and economic considerations against building the Stone Mountain Tollway."[31]

BOND's purpose was to "improve its area as a residential community." Its Statement of Purpose lists ten goals that, if achieved, would restore the neighborhoods to prosperity: "First, to reverse the trend of deterioration in housing and maintain density of living units appropriate to established community facilities, services, streets, and neighborhood identity." Here, BOND addresses a concern of many in the neighborhood, that density should not exceed its originally intended level. Many residents feared that after the Tollway fell through, the empty spaces would be used for low-income housing or housing projects on a large scale. BOND made clear that its plan would afford no more than a 25 percent increase in population from the 1970 level.

"Second, to facilitate the movement of traffic into, within, and from the community while minimizing the disruption of residential values and safety due to through traffic." Attainment of this goal can be seen today in the pedestrian-friendly layout of L5P. Furthermore, the BOND plan assumed that MARTA would be an integral part of providing alternative transportation into the area. Two stations were planned immediately—one in the I-485 right of way and another directly south of Candler Park.

"Third, to encourage the improvement and development of high quality schools to contribute to the educational experience of the whole community and enhance neighborhood identity." One aspect of this goal was to "expand educational opportunities to serve all age and economic groups," which required an increase in the number of educational facilities.

"Fourth, to retain the concentration of commercial activities around existing shopping nodes, resist incompatible commercial expansion into residential areas, and encourage the improvement of the quality of shopping facilities." The idea behind this was to "establish Little Five Points business area as the commercial hub servicing the entire community."

"Fifth, to develop adequate recreational facilities consistent with the density of development and desires of the residents of each neighborhood." BOND planned recreational facilities to serve all age and economic groups. Plans were readied for a softball diamond, a baseball diamond, a little league, tennis courts, swimming pools and a recreational center.

"Sixth, to conserve existing open spaces, points of historical significance, and aesthetic qualities." Much of the space leveled for the Tollway was to be converted into parks and open spaces. Also, houses deteriorated beyond repair would be demolished and the lots used for parks and open spaces.

"Seventh, to develop social and public services adequate to meet the needs of the BOND residential population." BOND's intent here was to improve and expand public services for sanitation, lighting, fire protection, etc.

"Eighth, to establish healthy reciprocal relationships with surrounding industrial institutions, coordinate industrial expansion compatible with residential patterns, and encourage local employment for the residents." BOND, according to Jordan, was "extremely community action oriented." Its idea was to develop the community first from within. Individuals living in the community were encouraged to work in the community, thus keeping money circulating within the community and, in turn, increasing the sense of community pride.

"Ninth, to recognize the unique elements of the individual neighborhoods within the BOND community, and strengthen those physical and

organizational aspects which encourage pride in the neighborhood and identity with the whole community." Crucial to BOND's success was gaining input from community members as to how the community might be improved.

"Tenth, to promote the recognition of the citizens and organizations of the community as the chief source for determining community goals and policies, both for the neighborhoods and for the public and private agencies that serve them." Again, BOND was created by and for the community that it serves. Any programs developed by BOND or the government would be placed in the hands of the citizens for execution. By recognizing the citizens of the community as being responsible for its achievement, BOND would "develop a pride of residence in this community among all its residents, guaranteeing that no one shall feel unwelcome by reason of age, background, occupation, life style, race, religion, income, or formal education."

This Statement of Purpose sounded utopian, but how exactly was this all going to play out? It looked like a long shot at best. Banks throughout Atlanta had "redlined" L5P, meaning that it was next to impossible for anyone to receive a bank loan to revitalize old buildings, start a new business or build a home in the area. This was especially disadvantageous because L5P was envisioned to be the center of commerce for the five BOND neighborhoods.

In response to this shortage of available credit, the BOND Community Credit Union was founded in 1972. On April 11, 1972, the BOND Community Credit Union was granted a federal charter and became the first community-based credit union chartered in Georgia's history. This came on the heels of a two-year struggle—spearheaded by John Sweet and Stan Wyse—with the National Credit Union Administration (NCUA). They were able to receive a charter despite the NCUA's reluctance to charter a credit union aimed at providing real estate loans. Once the charter was granted, it was the MCC (Mennonite Central Committee) that put up the initial $2,500 start-up money for the new BOND Community Federal Credit Union.

Another factor that necessitated the forming of BOND CCU was that the L5P branch of C&S Bank had the highest ratio of savings to loans of any C&S branch; that is, it was taking lots of deposits and giving out very few loans to people in the neighborhood. It is hard not to agree with Sweet when he says that "they were here to suck out of this neighborhood the accumulated capital of working-class people, bundle it all together and not lend it back to this neighborhood so we could use it."[32]

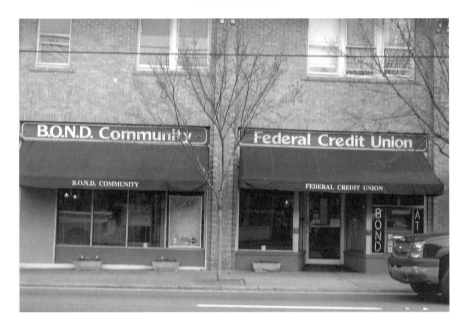

The BOND Community Federal Credit Union was one of the most successful and inspiring enterprises of the revitalization era and continues to serve the community. *Courtesy of Robert Hartle Sr.*

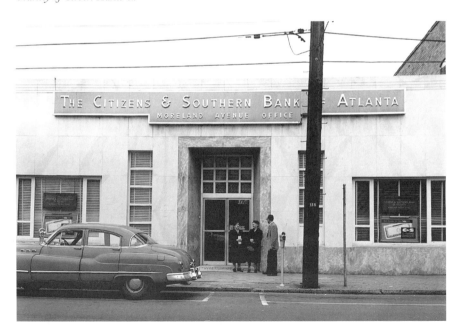

Now the Star Bar, the Citizens and Southern Bank of Atlanta was once the primary bank for L5P residents. *Courtesy of the Special Collections Department and Archives, Georgia State University Library.*

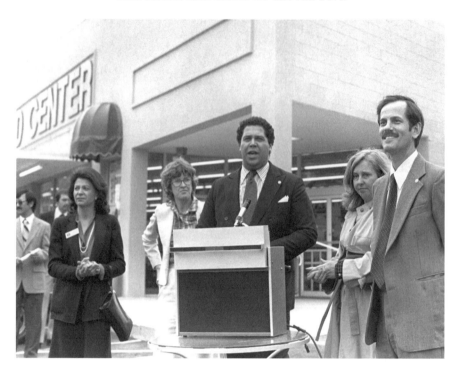

John Sweet (far right) smiles as Mayor Jackson speaks at the 484 Moreland building dedication. Also in attendance were Mary Davis (on Jackson's left), city council member from the sixth district; Elaine Wiggins Lester (on Jackson's right), an at-large council member; and Robert Kim (far left in picture with glasses and moustache), owner of the L5P Food Center. *Courtesy of Kelly Jordan.*

The success of this community credit union depended entirely on an intense degree of faith in the community and action within it. These young, "wide-eyed radicals" were putting up their own money as backing for other folks' endeavors. The board of directors was made up primarily of MCC members who were known for fiscal thriftiness. Initially, some board members believed that their best course of action was to reinvest dividends back into the credit union to ensure its security, rather than pay the dividends out to its membership. Sweet saw things differently. He believed that, since the credit union was originated to serve the poor, and if they were going to save at BOND, it had to be in their best interest. Sweet's point was well taken, and when dividends were initiated, they were at a full quarter percent over the nearest competitor, C&S Bank. Deposits increased as a result, but by the fourth quarter of its first year, BOND did not have enough reserve funds to pay out dividends.

What happened next is the stuff of legend. It also shows how minimal a budget the credit union was working with. To pay back dividends,

BOND needed a total of $210. The board members and some Mennonite volunteers took all the available reserve funds, borrowed a neighbor's truck and went peach picking. Their first stop was the Atlanta Farmer's Market, where they spent the reserve funds on sixty-five bushel baskets. Next, the resourceful crew was on its way one hundred miles south to Roberta, Georgia, to visit Sweet's good friend, Lou Becker. Becker had a peach farm and allowed the crew to fill the sixty-five bushel baskets with organic Georgia peaches. The crew members spent the remainder of the day selling peaches on the streets of the BOND community for $4 a bushel. By the end of the day, they had raised enough money to pay dividends and keep the credit union going.[33]

As I mentioned earlier, one of the struggles that BOND faced in trying to get an NCUA charter was the fact that BOND was giving out real estate loans. The NCAU threatened to shut down BOND in 1973 after BOND lent out $1,500—one-tenth of its total deposits—for a long-term loan for one of its members to buy a home. "NCAU had a fit!" said Sweet. "They wanted us to make loans for color TVs and we needed to be making home loans. Poor people didn't need color TVs, we needed homes."[34]

After some fruitful negotiations with the NCAU, BOND smoothed things over. The BOND CFCU was granted low-income status and was able to receive nonmember deposits. Bender had gone to Philadelphia and convinced the MCC to make a $50,000 nonmember deposit into the credit union. There was no risk for the MCC because the government, under the federal charter, guaranteed the money. Furthermore, since this was a nonmember deposit, the Mennonites did not receive a vote in the credit union, which, according to Sweet, was crucial because (though he saw the Mennonites as truly remarkable as well as genuine in their interest in helping the poor) he strongly disagreed with their methods of dealing with the poor. They would preach to the poor about living up to a strict moral standard in order to save money. "That kind of Calvinism is not going to help poor people," Sweet said to me. "What you need to be able to say to poor people is, 'I hear you; I'm going to help you; and we're in it together. We're going to lend you some money and help you buy a house. I want you to understand that this is a neighborhood organization that belongs to you.'"[35]

After the nonmember deposits were made, a Blue Ribbon Committee was formed, made up of any board member who had a suit and tie. These five people were organized to solicit stronger credit unions for large and long-term deposits. "We guaranteed people that their money would stay within

this community and would not be used to fund white flight." They were successful in doing so, and as a result, BOND CFCU was able to grant larger and longer-term loans. By late 1974, the credit union, which started with $2,500, had deposits of $101,390 and had booked 162 loans (most of which were real estate) totaling over $165,000.

Even before the community credit union opened, community consciousness had been raised through the circulation of BOND's monthly newspaper, the *Community Star*. The *Star* was a forum for the residents of the five BOND neighborhoods to express their views, concerns and hopes for the future. Furthermore, it was a way for BOND to keep people "in the loop" about changes in the neighborhood, revitalization efforts, community events and meetings, as well as to educate new residents about the benefits of the area and what it had to offer. For example, the September 1976 edition carried an article on the benefits of the BOND Community Federal Credit Union. Since the credit union was run on a volunteer basis, it was open from 4:30 to 6:30 p.m. every weekday so that volunteers could come in after work. The *Star* describes the new manager, Bonnie Zucker, as "taking her turn at this community-service job."[36] When I read that, I was amazed that a credit union manager was doing the job because it was "her turn." It is as if these people came from the pages of Sir Thomas More's *Utopia* and into L5P. Not only were they dedicated to the highest level, but also they really believed that what they were doing was going to work. The collaboration between the *Star* and the CFCU proved quite beneficial for the CFCU. For example, if someone bought a furnace with money loaned by the credit union, the *Star* would run a small story saying, "John Smith recently purchased a furnace for his home. The furnace was purchased with money loaned to Smith by the BOND Community Federal Credit Union." By 1985, the BOND Community Federal Credit Union had become Georgia's largest and fastest-growing community credit union, with over two thousand members and $2 million in assets.[37]

The *Star* was also vital in keeping the community informed of revitalization efforts. The Little Five Points Business District Revitalization Plan was thoroughly outlined on the front page of the December 1976 issue. A team of economic, architectural and traffic planners, funded by the City of Atlanta, was assembled to outline a feasible revitalization plan. In sum, there were three aspects outlined for physical development and rehabilitation: the separation (and strengthening) of a pedestrian precinct of specialty shops and facilities from the auto-oriented businesses and the creation of a shopping district focal point; the development of a cluster of recreational, entertainment and

cultural uses around the Euclid Theatre; and the development of a roadway system that would encircle the business district, providing access to parking at the rear of stores, allowing for a separation of through traffic from shopping traffic and reducing pedestrian/auto conflicts.[38]

Kelly Jordan recalled his seven years with the *Star* as "business manager, i.e., ad salesman" and the old-style "paste-up" of the layout at the homes of Betty Knox, Susan Hamilton and others. The *Star* was circulated by volunteers to about five thousand homes throughout five neighborhoods. By seeing a solid, detailed revitalization plan on the front page of the newspaper, residents could not help but be encouraged, and encouragement was what people living in and around L5P needed. The strength of the community was the belief in its residents that they were part of something special—using grass-roots democracy to build up L5P from within. The *Star* circulated for about ten years and brought not only a voice but also hope to a community that, at many times, had little else to lean on.

BOND was successful in almost everything it undertook. It even started a day-care facility, which today is called Inman Park Cooperative Preschool. Eventually, as the BOND neighborhoods grew, they began forming neighborhood organizations of their own—Inman Park Restoration, Inc., Lake Claire Neighbors, Little Five Points Business Association and so on. Though BOND as a neighborhood development organization is no longer in existence, its offshoots still are. Without the dedicated individuals who volunteered for BOND, it is doubtful that revitalization would have occurred.

BOND was not the only group at work redeveloping in L5P. Don Bender, along with a few others, started the Atlanta Intown Development Corporation (AIDC) in 1972–73. Bender said:

> *Initially, the purpose of the AIDC was to buy and renovate houses and resell them to people who wanted to move into the neighborhood but didn't have the stomach to renovate them themselves. These were of course times when people didn't have the money to just pay somebody to come in and renovate their house. Generally these were activist types, more politically progressive folks who didn't tend to be "well heeled." So this was an idea that we could renovate these* [houses] *for folks who weren't looking for something so marginal.*

At the time, the AIDC was struggling to upgrade the housing stock in L5P.

In 1975, the AIDC bought a strip of eight storefronts on Moreland Avenue along what is now Findley Plaza. One of those storefronts was home

to the filthiest, most run-down, seediest bar possibly in all of Atlanta—the Redwood Lounge. Everyone I interviewed who was active in L5P at the time, without fail, mentioned the Redwood Lounge. It did not matter what I was asking them about. I could ask, "What made you decide to open up in Little Five?" or, "So who or what was it that brought the people in the community together so well?" and the conversation would turn to the Redwood Lounge. I was talking to Kelly Jordan about it, and he described exactly what I had envisioned this place to be. He said it "was like something out of a Tarantino movie. People would get out of jail and go there and start setting up contacts; there were stabbings, and prostitution."[39] It was just raw Americana. Forget Tarantino—the way some people remember it, the Redwood Lounge could be something out of a Rod Zombie movie.

In an article published in *Creative Loafing*, the late Lou Arcangeli, former chief of police, describes a time in the early 1970s when he was assigned to patrol the Redwood. Arcangeli told *Creative Loafing* that his supervisor cautioned him about the lounge. He told Arcangeli that "if someone challenged me, I'd have to whip their ass right then, or else I'd have to whip 'em every night." Arcangeli described his first night in the bar (keep in mind that he is a cop), saying that a bar patron approached him and asked, "'Who's that four-eyed fuck?' So, I had to take him outside and hit him once or twice. The next night another guy said he was going to have to kick my ass. But the guy from the night before stood up and said, 'Don't do that. He's a good guy. He whipped my ass last night.'"[40] In retrospect, Arcangeli had a sense of humor about it, but at the time it could not have been very funny.

"It was a dive," said Bender. "That was one of the concerns when we bought it. We wanted to change it into something that would serve the community rather than something that was a difficult hurdle for the community to get over. We worked with the owner," Bender said, describing the buying process. "He had always wanted it to be something better, but it became known as the first stop when you got out of the federal pen. It seemed that it would take something more dramatic than him turning it around." The people who actually bought and ran the former Redwood Lounge called themselves the Little Five Points Community Pub Inc. "We took it on not having much business experience. It was a gamble. [The idea] was sold as 'don't put any money in that you're not willing to lose,'" explained Bender. "So we got together what in today's terms would be a very small investment—$30,000—from seventeen different people."

Revitalization

From what was probably the seediest bar in Atlanta emerged the Little 5 Points Community Pub, which opened its doors on April 8, 1977.[41] "It got a lot of attention," Bender added. "We opened with a big hoopla; Mayor Jackson was there, and we had a musical group perform." The way it functioned was as a corporation that met monthly to decide on policies and financial issues. The pub was completely remodeled and featured common bar food—sandwiches, salads and appetizers—as well as beer and wine. Since the idea was to make the pub a place that could serve the community, the pub sponsored all sorts of events, including live bands, monthly art shows featuring artists from the community, Monday night poetry readings and monthly benefits for different community organizations, such as the BOND *Community Star* and Charis Books. Also, after Seven Stages moved in next door, it and other theatre groups would do presentations at the pub.

Kelly Jordan designed the new pub and worked with Earl Moses in an AIDC office next door. Jordan had been the ad manager for the *Star*, was involved in a few home renovation projects and, in his words, was "starting

The Little Five Points Community Pub. The "Pub" was more than just a watering hole; it was a forum for community meetings, poetry readings and live music. It replaced the infamous Redwood Lounge, one of the seediest bars in the city. *Courtesy of Kelly Jordan.*

In an effort to improve acoustics at the L5P Community Pub, Beth Passavant and others created this web on the ceiling from material that they found at a bra factory. It was called "the Loveable Bra," and the holes in the web are where the bra pads used to be. "The Loveable Bra" had to be replaced every week because it was susceptible to dust and nicotine residue. *Photo by Beth Passavant. Courtesy of Reid Jenkins.*

Reid Jenkins took this photo for a girlfriend of his. The woman in the middle with the shocked look on her face was Jenkins's girlfriend, who was throwing herself a going-away party. The party at the pub was a girls-only "hat party," but Jenkins was allowed to come along and take pictures. *Courtesy of Reid Jenkins (www.freejoye.com).*

A 1978 program guide from the L5P Pub. *Courtesy of Reid Jenkins (www.freejoye.com).*

This page: Nowadays, the L5P Halloween parade is one of the biggest Halloween attractions in the city. These pictures are from an L5P Halloween costume party in either 1977 or 1978. *Courtesy of Reid Jenkins (www.freejoye.com).*

Another picture from Halloween. The woman falling on top of the other one is Patty Kunkle. Kunkle was a longtime L5P resident who owned what was probably my favorite L5P shop, IFO. IFO specialized in Frisbees, including disc-golf Frisbees, as well as other airborne toys, posters, cool trinkets and T-shirts. *Courtesy of Reid Jenkins (www.freejoye.com).*

to get my spurs." But it was at an L5P Businessmen's meeting that he had his "epiphany." Jordan told me:

> *We were trying to mix with the older guys who owned all the property and trying to get them to upgrade. Now keep in mind, we were the people who had been fighting the Freeway coming through…so there was some hostility there. And I remember Mr. Findley* [John Findley owned Findley Hardware Store in L5P; Findley Plaza is named in his honor] *called me out at one of those meetings. I was trying to tell him, "We've got all this home renovation stuff going on Mr. Findley, you ought to stock this and this, and get some stuff that appeals to the new market. You shouldn't be negative about the Freeway not coming through, 'cause there's a lot of business here now." He looks at me and says, "Let me tell you something you whippersnapper, I'm seventy years old, I'm through, I'm going to retire. You need to quit telling me what to do and just do it yourself." I thought to myself, "You know, he's right."* [42]

Sometime in late 1976 or early 1977, it came to Jordan's attention that the Point Center building (the long building along Moreland Avenue that now

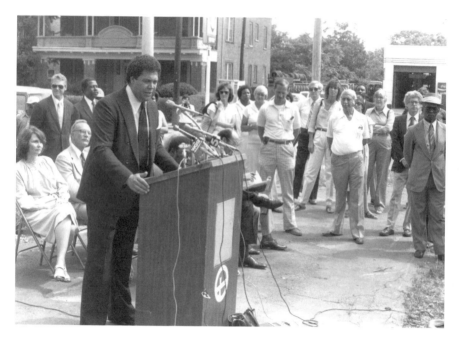

Maynard Jackson was the epitome of a "hands-on" mayor. *Courtesy of Kelly Jordan.*

houses Abbadabba's, BOND Community Credit Union, Coyote Trading Co. on the first floor and offices on the top floor) was going on the market. C&S Bank, which used to be located where the Star Bar is now, was considering tearing the building down for parking because it was in dreadful shape. Earl Moses, a business associate of Jordan's, let him know that the building was for sale, and Jordan, ever the idealistic conservationist, knew that he had to buy it. Wilma Stone had purchased the Point Center building a couple years earlier for just $43,000 and was now asking $75,000, a figure out of Jordan's price range. However, Jordan and Moses—whom Jordan described as charismatic—were able to convince Ms. Stone to accept a $25,000 down payment, also out of Jordan's price range. Yet there was no stopping him. Jordan begged money from all of his friends, started a small company called the Point Center Corporation and eventually came up with enough for the down payment. Within a year, Jordan was regretting the purchase. The building was falling down, and there was no money to fix it up.

If someone had told Jordan then that he was in the right place at the right time, Jordan would have laughed in his face. But the stars were aligned for L5P, and Jordan and the rest of the neighborhood were about to meet a really good friend.

Revitalization

In 1973, the City of Atlanta adopted a new charter. Since its incorporation as a city, a board of aldermen had governed Atlanta, which was a citywide governing body so that there was little neighborhood representation. With the new charter, a city council was elected to control legislative and oversight measures. The city council is elected by districts and therefore members must work harder to gain support of the neighborhoods that they represent. The mayor now had, under this new form of government, more control over day-to-day operations. Soon after taking office, Atlanta's first African American mayor, Maynard Jackson, started pushing for neighborhood revitalization in two neighborhoods in particular: Lakewood Heights and Little Five Points.

Jordan gives Mayor Jackson credit for saving his Point Center building. After Jackson was elected, Jordan successfully borrowed money from the Small Business Administration. "It was really because of Maynard that I was able to get the Point Center building financed. We eventually borrowed money from the Small Business Administration in Washington. A group

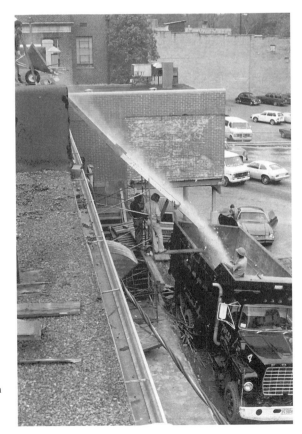

Construction crews dump debris into a dump truck behind the Point Center building during its renovation in 1978. *Courtesy of Reid Jenkins (www.freejoye.com).*

A close-up look at the renovations going on within the Point Center building in 1978. *Courtesy of Reid Jenkins (www.freejoye.com).*

A construction worker looks on as a garage behind the Point Center building falls to the ground. It was originally a garage used to house Georgia Power service vehicles and eventually became a flea market. Jordan would have liked to save the building but eventually had it removed so that the Point Center building would have a parking lot. *Courtesy of Reid Jenkins (www.freejoye.com).*

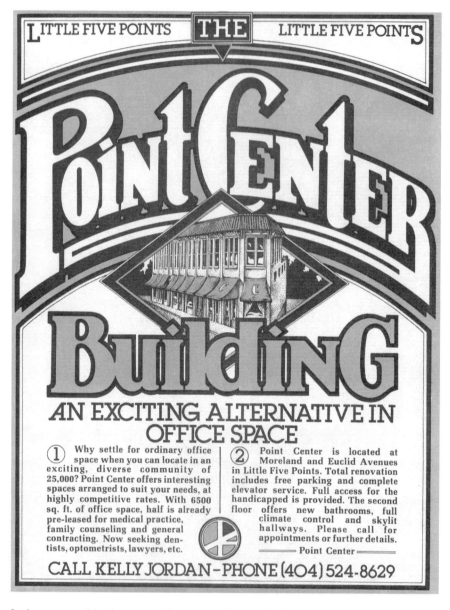

Jordan sent out this ad to prospective tenants after purchasing the Point Center building. *Courtesy of Kelly Jordan.*

called the National Development Council came to town promoting SBA loans, and Maynard said, 'Hey, I want you to come down to Little Five Points and help the people down there get going.' They came to town looking for places to put the federal loans to work."

Revitalization

It became evident rather early on in Jackson's administration that he was not just paying lip service when he spoke of revitalizing L5P. With a little nudge from Mayor Jackson, the city council took notice of the dedication and hard work going on in L5P and, in 1975, allotted $350,000 for site improvement activities and another $250,000 for business assistance loans. The funding came from the U.S. Department of Housing and Urban Development under the Housing and Community Development Act (CD) of 1974. With that money, the city hired a firm of architecture and planning (Toombs, Amisano and Wells), a firm of economic consultants (Hammer, Siler, George and Associates) and an association of traffic planning associates (Transportation Consultants) to create the L5P Revitalization Plan. Meetings were held among members of the firms and members of the L5P business and residential community. In the plan's acknowledgements, it is stated that approximately two hundred people provided input that was used in the plan, but only fourteen people from the L5P community were recognized by name, one of whom was Jordan.

The 113-page plan was submitted to the City of Atlanta's Department of Community and Human Development in December 1976. In keeping with the community spirit, a survey was sent out in the *Star* so that planners could identify residents' concerns with the area. Of the residents who responded, 40 percent said that they did not shop in L5P at all. They cited three reasons: the overall appearance of the business district; the poor quality and lack of variety in merchandise; and the parking and traffic problems. In addition, 47 percent of those surveyed said that they rarely shopped in L5P (once or twice a month), and even the 13 percent who frequented the area cited concerns about the poor appearance of the business district and the poor quality of the merchandise.

The plan also concluded that the area did a poor job in marketing to middle- and upper-class clients, as evidenced by the fact that about 75 percent of businesses sold little other than used, off-brand and closeout goods. In 1975, residents within the trade area spent $16.2 million on food at home. The numerous grocery stores in the area were only taking in 11 percent of that money. The revitalization plan concluded that a grocery store in L5P was paramount for economic stimulus and could raise this percentage to 67 percent and that the grocery store should be about 20,000 square feet. The best location for the grocery store, planners assumed, would be on Moreland Avenue because the traffic passing through Moreland each day would draw in people from outside the area as well. Secondary in fiscal importance was a general merchandise store.

Little Five Points was a source of pride for Mayor Jackson. L5P and Lakewood Heights were the two primary neighborhoods where Jackson pushed for neighborhood revitalization. He spent a lot of time in these two neighborhoods, getting to know the folks who lived and worked in them. Mayor Jackson is seen here visiting with an employee at an L5P dry cleaner. *Courtesy of Kelly Jordan.*

Kelly Jordan, Councilwoman Mary Davis (far left) and State Representative Paul Boster (on Jordan's right) with his son Nathan look on as Councilwoman Panke Bradley-Miller prepares to cut the ribbon at the reopening of the Point Center building. *Courtesy of Reid Jenkins (www.freejoye.com).*

Revitalization

Planners determined that the sales volume potential in L5P was too low to attract a department store but high enough to attract a smaller general merchandise store at a size of 13,000 to 14,000 square feet. The plan describes other retail opportunities: "Apparel and accessory stores should be expanded from 1300 to 10,000 square feet. An additional 7000 square feet of specialty stores such as books, jewelry, sporting goods, antiques, hobbies, gifts, and second-hand merchandise stores can be supported."

The pedestrian environment in the area was very poor. Sidewalks were cracked, and their curbs were uneven, causing L5P to look run-down and neglected. As a result, repaving of sidewalks and reconstruction of curbs were deemed vital, as increased pedestrian access was essential for the environment that planners were trying to create.

The most costly area of improvement within the plan was street modification, with an expected cost of $150,000. Improvements included closing off the intersection of Seminole and Moreland Avenue and building a Seminole-Colquitt connector road, as well as a Mansfield-Euclid connector, to alleviate traffic on Moreland. Both McLendon and Euclid were to be widened at their respective intersections at Moreland. The plan also included the acquisition of an abandoned service station at the intersection of Moreland and McLendon Avenues for reconstruction as a Euclid Avenue turnaround and parking area. This turnaround was planned with an emphasis on aesthetics, with numerous species of trees to be planted in the turnaround area and in the surrounding sidewalks. What is now called Findley Plaza was also planned, also featuring many kinds of trees and flowers, as well as wood slat benches.

It was according to this plan that Jordan continued rebuilding the neighborhood. He built the shopping strip that is now home to the Junkman's Daughter, Savage Pizza and the L5P Pharmacy. One building was designed around Ira Katz's pharmacy. Before Junkman's and Savage moved in, there was a grocery store directly on Moreland Avenue as the plan suggested, owned by Robert Kim, one of Atlanta's first Korean grocers.

Barbara Joye, a former writer for the radical newspaper the *Great Speckled Bird*, reminded me of something that is very important to keep in mind when thinking about revitalization: usually when revitalization occurs, gentrification does as well. While the revitalization of L5P was extremely impressive and, for the most part, done with the best of intentions, there were people who suffered as a result. As the neighborhood was being cleaned up and turned into a productive, community action–oriented area, property values and taxes began to increase. In turn, some working-

A young Kelly Jordan looks on as Mayor Jackson prepares to cut the ribbon at the 484 Moreland Avenue building. *Courtesy of Kelly Jordan.*

class families with children were not able to afford living in the area and thus were displaced. This is the case for any economically deprived neighborhood that undergoes revitalization, but it is by no means a reason not to improve an area. The two things—revitalization and rising property values and taxes—go hand in hand.

If L5P had not been revitalized, it would more than likely have been cleared out to make room for a highway. Instead, through the hard work of mostly honest and dedicated individuals, it was transformed from a run-down commercial and residential district to a shining example of grass-roots democracy. It is, however, important to know that while the majority of folks in L5P wanted revitalization, there were some families that were displaced as a result of it.

Chapter 3

CULTURAL IMPROVEMENTS
From the Euclid and L5P Theatres
to Seven Stages and the Variety Playhouse

The arts were more prevalent in L5P during the early stages of revitalization than ever before. Even today, many people consider it an "artsy" part of town. Yet during this era, L5P was full of established and aspiring artists who used every medium to express themselves. Music, poetry, painting, sculpture, photography, theatre and film—all forms of art were represented, and artists were united in the Little Five Points Arts Alliance. I asked Scott Outman, L5P Arts Alliance member, about the organization, and he said the following:

> *The Little Five Points Arts Alliance brought together aspiring and accomplished artists in all media who sought to increase their opportunities for exhibiting and occasionally marketing their work. We created events, like the Little 5 Points Arts Festival, published freelance journals and inhabited any available storefront to present group art exhibits. We successfully competed for city, state and national art grants and found willing partners amongst the small business owners in L5P (Little 5 Points Business Association). Some of our efforts were great triumphs, attracting hundreds to the Little Five Points community, while others were poorly attended affairs that were nonetheless important to our personal growth as artists. Throughout it all, our main focus remained the mutual support of any artistic effort and friendship. Our group was a true alliance. The details of exactly what we did are no longer important, the biography of any individual member of the Alliance not relevant. We just were.*

Two cultural landmarks that Jordan desperately wanted to save from the wrecking ball were the Little Five Points Theatre and the Euclid Theatre. At this point, the era of the single-screen theatre was coming to an end. The multi-screen megaplex theatres were taking over, and there were really only two options for a single-screen theatre: the cinema draft house or the dollar theatre. The cinema draft house can be seen today in the Buckhead Backlot, where moviegoers can enjoy beer, wine and a meal while they watch the movie. Dollar theatres are all but extinct nowadays. Jordan's first move was to get hold of the two historic theatres and then worry about what to do with them. They were owned by the Storey Theatre Co., which was connected with the Georgia Theatre Co. that controlled so much of the theatre business in Georgia that an antitrust lawsuit had been brought to break them up. The judgment was handed down in April 1982. Southway Theatres Inc., the owners of the Jonesboro Twin Movie Theatre, sued the Georgia Theatre Co. in a private antitrust lawsuit in which Southway contended that the Georgia Theatre Co. was making illegal, behind-the-scenes deals with movie distribution companies. The Fifth Circuit Court of Appeals overturned an earlier decision in favor of the defendant, Georgia Theatre Co., citing that Southway Theatres Inc. had proved "that competing theater chains and national film distributors conspired to deprive it of opportunity to license first-run films,"[43] specifically in regard to the Jonesboro Twin Movie Theatre.

"I was dealing with a guy named Fred Storey," Jordan told me. "He had married into the Georgia Theatre family. I go and see Fred Storey and his right-hand man, James Edwards, with this great woman named Imogene Blair." Blair was an amazing woman, according to those who knew and worked with her. She was one of the first, if not the first, female real estate brokers in Atlanta. She had worked in L5P in the past to save a couple of old grocery store buildings in the neighborhood and was successful because of her ability to mediate between the families who had owned and abandoned them and the redevelopers in L5P. Jordan continued:

> *Imogene somehow knew Fred Storey. So she introduced me to him. Fred Storey was a real character. He was already up in his years by this time and an archconservative. He had this right-hand man named Edwards who had a crew cut—real military guy and just a trip to talk to. I'm sure that from their perspective I was this neighborhood half-hippie nut, who was coming out there and telling them how to open these old theatres. So I would go out there to see them, and they were kind of patting me on the head, all the while thinking to themselves, "We've got to tear these theatres down quick."*

In hindsight, Jordan realizes that they were trying to keep him happy by giving him a false sense of hope, when in actuality they had no interest in saving these two theatres. Old theatres in L5P were just a nuisance to them. Jordan explains:

> *They're telling me, "Oh yeah, we're thinking about it, maybe we'll do the dollar theatre or something." In the meantime, I get a call from our new city councilwoman, Panke Bradley, who was just elected in our new form of city government.* [Jordan reiterates that in the old form of government he would have never received a call.] *She says, "Kelly, aren't you talking to those people about those two theaters in L5P?" I said, "Yea, yea, I am." She says, "Well, they just issued a demolition permit down here at city hall. They're going to tear them down starting tomorrow." I was so stunned...shocked that all I could think about doing was asking her, "Is Maynard in town?" She said, "Yeah, I think he's in his office." So I said, "Will you go into his office and tell him? Cause he cares so much about Little Five Points and it says in the plan that we're supposed to save these theatres. Will you ask him if he'll call them* [Storey Co.] *on the phone?" So she did. She went into his office and told him. And as I was told from Imogene, he* [Mayor Jackson] *called Fred Storey on the phone. I think that just blew Fred's mind.*

Storey agreed to meet Mayor Jackson on Euclid in front of the two theatres, but he made it clear that he did not want Jordan at the meeting. Sure enough, Jackson's pull was enough to sway the stubborn old man. Shortly thereafter, Jordan received a call from Edwards, Storey's right-hand man, who said, in a gruff, drill sergeant–like voice, "All right Jordan, we'll lease you the buildings for fifteen years but that's it; after that we're going to tear them down if we want to."

Jordan said:

> *I remember this clearly. I figured, at the time, that I would in essence sort of outlive them. Mr. Storey was getting on up in years and I thought that when he died things would change. I think I did know some of the other members of the family, and I thought that they would be easier to deal with. So I agreed to this lease, which was crazy because on a lease that short you can't borrow any money to fix them up. Not only that, but they were both in extremely bad condition.*

The Euclid Theatre was in the worst shape. It first opened its doors on October 4, 1940, and the first movie shown was *My Favorite Wife*, starring Cary Grant and Irene Dunne. Lucas and Jenkins Theatres, the same company that operated the Fox Theatre at the time, built it.[44] The Euclid had not functioned as a movie theatre since 1962, and its roof had been leaking for ages, completely ruining the interior. Compounding the problem, a junk dealer had leased the building prior to Jordan and had left so much junk behind that it covered the theatre from front to back and stood about fifteen feet high. To make matters worse, the junk dealer died at the time Jordan signed the lease, and Storey, in his distinct, anything but amiable tone, told Jordan that the junk was now his. "So I looked at it and thought to myself, 'I'm gonna hold the biggest garage sale in history.'" He did and ended up making about $12,000 in the process. The sale was phase one. Phase two was a free giveaway. There were a lot of good raw materials like copper piping, as well as many large appliances like sinks, and even a giant coffee maker. People could come and take one giant item that they wanted for free but had to take another giant item that they didn't want. The first two phases took care of the junk and left Jordan with a nice profit. If it were only that easy! An employee of the Environmental Protection Department of the State of Georgia showed up and noticed the fifty-five-gallon metal drums.

A close-up look at all the junk that had piled up in the Ellis Cinema. *Courtesy of Kelly Jordan.*

Inside the drums were cleaning agents, pesticides and other chemicals, all of which were so old that they had been banned by the time Jordan inherited them. The environmental agent sent him a "cease and desist order" until the chemicals were disposed of. By the time a company came out, siphoned out the barrels, cleaned them and then disposed of the waste, Jordan had paid the company all the money he had made in the garage sale.

Now all he had was an empty, deteriorated building. Guess who saved the day again? The Jackson administration created the Atlanta Economic Development Corporation (AEDC), led by Jim Martin at the time, which brought in urban development action grants and small business administration loans to neighborhoods in order to revitalize and redevelop them. The city also provided matching loans to these projects, where it would match 15 or 20 percent of a loan acquired from a bank or an investor. Jordan says that all of the new businesses in L5P were using at least one of the loans. "We were good about paying them back too. By the time we got around to restoring these theatres we had already started paying back some of these loans." By paying back loans, businesses were heightening credibility with the government and with outside investors. And when people looked at L5P in the late seventies, they did not see a failed redevelopment project—they saw businesses where people were actually shopping and things were happening.

City governments do not put money into neighborhood revitalization just out of the goodness of their hearts. They put money into neighborhoods because they get something back. When a neighborhood goes from being an eyesore avoided by people who are not looking to score drugs or buy prostitutes to a place where people see new, appealing businesses spring up and affordable, renovated housing become available, the tax base of that neighborhood drastically increases. The money that is lent to revitalize the neighborhood pales in comparison with the money generated via sales and property taxes. L5P was not, by any means, at that level in the late 1970s, but it was looking more and more as though it could be.

Along with the loans that were coming in, Jordan believes (and all that I have found indicates that he is correct) that most people doing the redeveloping were not in it for the purse but rather because they believed that they were creating something unique and amazing. Without them, the money would not have worked. "There was a cadre of people here, of which I was definitely an important one, who were committed," Jordan said, with an emphasis on "committed." "I wasn't here to make money. Neither was Don [Bender] or any of these other people, pretty much…It was first about, can we save this area? Save it from being wiped out, stop the Freeway, rebuild

Beth Passavant gets sprayed by fellow volunteer Roland Heath during the 1977 L5P Litter Lift. Volunteers even planted flowers and shrubs along the side of Moreland Avenue where Findley Plaza now sits. They were treated to free beer from the pub and free food from Zesto's. *Courtesy of Reid Jenkins (www.freejoye.com).*

the community? You know, it was the times and it was the sentiment. You've got to learn your way through the financial system to do that, but for us it was a tool, not an end."

This growing knowledge of the financial system and the enthusiasm of the Jackson administration for L5P afforded Jordan the opportunity to borrow money for the theatres despite having only a lease. The issue remained: what to do with the theatre? Dollar cinemas were not working out well anywhere in 1983, and there was no reason to expect that things would be different in L5P. Jordan explains his first course of action:

> *I went to George Lefont, who controlled the art cinema business at that time. He had about four or five little theatres, but he felt like it* [Euclid Theatre] *was too big. Besides, he had all the theatres he wanted. So George said no. Then there was George Ellis. George Ellis, for years, had this little, tiny art cinema in Ansley Mall called the Film Forum. He was, in a way, the original art cinema purist guy. Anyway, it came to pass that we heard he was going to lose his lease over there. I met George, and along with his investors, we came up with the idea that we would start the Ellis Theatre. We were going to have two screens, and George was going to live there, upstairs.*

Unfortunately, early in the restoration efforts, Ellis passed away. While some might think that the death of a man who was supposed to run and live in the theatre would signal the end, that was not the case, for Mr. Ellis's financial backers were also his biggest fans. Along with Jordan and his investors, Jill Kirn and her husband, Glenn Sirkis, invested $250,000 in restoring the theatre, not including the fifty-foot screen, Dolby sound system, new top-of-the-line projection equipment and 463 new seats added later. "We put a lot of time into making sure the place had great acoustics," said Jordan. "We were on such a budget that we couldn't really afford fancy acoustical panels. Somehow it came to my attention that they were selling these perforated metal panels that used to be the ceiling of the old Atlanta airport. So I went down there and bought a bunch of them for a dollar apiece. They delivered them and we installed them for acoustics." These panels remain along both walls of the building. Kirn and Sirkis announced at Ellis's memorial service that the theatre would be named in his honor. It opened for business on October 4, 1984, and for years it was successful.

Critics and audiences loved the theatre, voted "Best in Atlanta" by *Atlanta* magazine; it even broke box office records with the release of the 1984

This 1983 photograph shows both the old Euclid Theatre (right) and the old Little Five Points Theatre (left) shortly before they were opened as the Ellis Theatre and Seven Stages Theatre, respectively. The Little Five Points Theatre building, at the time, was home to Dancer's Collective. *Courtesy of Kelly Jordan.*

movie *Mass Appeal.* However, the cinema industry was changing in the mid-1980s. Theatres were becoming larger and larger. Four-screen theatres were giving way to eight-screen theatres, which were giving way to twelve-screen theatres. The days of the single-screen theatre were coming to an end. Movie distribution companies were reluctant to give movies to the Ellis because in the multiplex theatres, when a movie loses steam, they can move it to a smaller screen within their own theatre and it keeps making money. In a single-screen theatre, when a movie loses steam, it is immediately replaced with something else. "Between the distribution companies and George LeFont, we just couldn't get any good movies," Jordan explained. "LeFont had multiple screens, so he could convince them, every time a good art film came out, that he could move it around his different theatres and he'd get the movie." The financial burden became too great, and Kirn and Sirkis knew it. "We just aren't big enough fish," Kirn told the *Atlanta Journal-Constitution* in 1988. "It finally sank in that we weren't allowed to be in the movie business."[45]

After the Ellis closed its doors in August 1988, Jordan faced the same dilemma again—what to do with the building? But this time, he did not just

Record-setting crowds packed the Ellis cinema for *Mass Appeal*. The movie, starring Jack Lemmon, was considered a flop but did so well at the Ellis that Kelly Jordan received a "thank-you" letter from Lemmon. *Courtesy of Kelly Jordan.*

have an old run-down building but rather a beautiful theatre. Enter Paul Blane, former manager of Hollywood stars such as Mel Torme and Jayne Mansfield. Jordan described him to me as "this weird old Hollywood retread dude...he talked like old Hollywood. And he said we could have this place where we'd get the aging stars of the entertainment industry, who are way past their prime...and we'd call it the Variety Playhouse." Blane envisioned some of the most ridiculous scenarios imaginable to play out onstage. Before the playhouse opened in 1989, he told the *Atlanta Journal-Constitution* that one of his early ideas was a live talk show starring Sylvester Stallone's astrologist mother and claimed that "Stallone [Sylvester, not Frank] said he would be a guest on the show after it got started."[46]

Blane put on a few shows, but audiences did not seem to notice. When he was not inviting old celebrities to get drunk and dance the Charleston in front of thirteen people, he was subleasing the Variety Playhouse to a music promoter named Steve Harris, owner of Windstorm Productions. "Steve put on a few shows there, and I noticed that his shows were great," Jordan said admiringly. "They were successful, they had good music and it was clear to me that Paul Blane wasn't going to make it." Harris was putting on shows all over Atlanta, but Jordan saw the possibility for a great partnership with Harris

and offered him a full lease on the building in order for him to concentrate solely on booking shows at the Variety. Harris was hesitant about the idea and voiced concerns about whether his business could survive in L5P. So Jordan made him the best offer he could think of and put it down on paper. "It was one of the best propositions I ever came up with. I told him, 'Okay, well I'll tell you what. We'll write it so that if you don't make any money, you don't pay us any money. Not only that, I'll give you six months free to get started…if you don't make any money you can bail out.'" Harris took the offer, and the rest is history. The Variety Playhouse is one of Atlanta's most celebrated music venues, winning the *Creative Loafing* award for "Best Concert Venue" every year from 1999 to 2009. I have been going to shows at the Variety since 1998 and have yet to find an indoor venue with better sound or atmosphere.

The Little Five Points Theatre opened just a few weeks before the Euclid, on September 21, 1940. Mion & Murray operated the theatre at 1103 Euclid Avenue, which cost about $75,000 to build. Opening night featured a double bill—*These Glamour Girls*, starring Lana Turner and Lew Ayres, and *In Old Monterey*, starring Gene Autry.[47] The Little Five Points Theatre building was first renovated for a dance outfit called Dancers Collective. Joanne McGee, whom Jordan calls "the Grande-Dame of dance in Atlanta at the time," and her husband, a prominent local attorney, wanted to create Dancers Collective as the Mecca of dance in Atlanta. "Of course, arts really mattered more back then than they do now," Jordan recalls. "You had the Bureau of Arts and Cultural Affairs, which really had a lot more mojo than they have now."

McGee signed a sublease on the building and put up some of her own money, which, along with money obtained from various grants, proved sufficient to get renovations underway. Renovations were indeed underway on the building, now called the Dancer's Collective, and in a hurry. Jordan describes a major mishap that occurred while they were getting ready for opening night:

> *We were rushing to get ready for this grand opening—it's always like that—and we had this great big wooden floor we had put in to dance on and the contractor sanded it and put the sealing on it. He wanted to make sure the sealing dried because we were two days away from our grand opening. His brilliant idea was to turn the heat up. He did this late at night and then went home. The building's sealed up, and you've got all these fumes that get sucked down into the furnace…So I get a call from our old electrician Wesley Pruett at about four o'clock in the morning and he says, "Son, you'd better get down here. The dance place just blew up."*

It turned out that the entire roof had been blown off the building in this massive five-alarm fire.

Luckily, Jordan was insured, so there was money to rebuild, but the city was not going to let that happen. There were numerous building codes that the Collective was in violation of: it was too close to the street, its marquee hung too far over the sidewalk, etc. However, the building was grandfathered, meaning that current building codes don't apply to it since it was built during a time when these codes did not exist—with one exception. If a building is over 50 percent destroyed, it loses its grandfather status. Such was the case with the new Dancer's Collective. This looked terrible for those involved. It looked as if, after all the money and hard work put into rebuilding and improving this beautiful old building, it was going to be torn down. Mrs. McGee was very passionate about dance and apparently not ignorant about the persuasiveness of a bunch of beautiful young women, either. Jordan said, "We got all the dancers together and Mrs. McGee, and we brought them all down to visit the chief building inspector, Norman Copeland. And they just sat there and pleaded with him and said, 'Please Mr. Copeland, we've got to have our dance theatre!' So he agreed to come down and look at the situation. Luckily, upon further

A group of dancers poses like manikins around an L5P storefront. In the top row, behind the window and second from right, is Joanne McGee. *Courtesy of Kelly Jordan.*

inspection, it turned out that the building was only 48 or 49 percent ruined. And we rebuilt it," Jordan said with a laugh.

In 1979, Del Hamilton and Faye Allen opened Seven Stages Theatre just a few blocks from the old Euclid Theatre. Their mission was to "create a haven for artists and audiences to address social, political, and spiritual issues present in their daily lives."[48] At first, Seven Stages could not afford to hire a staff and relied on local artists who volunteered. Despite the fact that performers and audiences were constantly disrupted by cue balls slamming into billiard balls from the pool hall next door, reviews were generally positive for the works put on at Seven Stages. Five years later, the pool hall was no longer a distraction. Its owners lost their lease, and Seven Stages had enjoyed enough success to rent that space as well, nearly doubling in size.

The new, expanded theatre opened in 1984 with *Earthlings* by Jim Grimsley. In 1987, Seven Stages caught headlines with another Grimsley play called *Mr. Universe*. The *Atlanta Journal-Constitution* praised the boldness of the now-established theatre, which had recently moved from 430 Moreland Avenue into the Dancer's Collective. "A lot of theaters claim to take artistic risks, but none has taken chances more consistently than Seven Stages. With tonight's opening of Jim Grimsley's audacious 'Mr. Universe,' the Little Five Points theater enters its ninth season with characteristic boldness, daring to become the only Atlanta theater to produce a season devoted exclusively to new plays."

The audacious new play was described by Grimsley as an "offbeat tale of two drag queens, the hooker with a heart of gold and a sweet, muscle-bound bimbo," all taking place in the underground sex world of New Orleans.[49] In 1988, *Mr. Universe* embarked on a nationwide tour—the first in Seven Stages history—starting its run at the New Federal Theatre in New York City.

In January 1987, Seven Stages took on the lease at the Dancer's Collective. Seven Stages transformed the building into two separate theatres: a proscenium (one with an arch as its centerpiece, through which the audience views the play) main stage and a "flexible-seating black box." This afforded the company twice as much space as it had before. Dressing rooms were also added. In 1989, the Seven Stages Theatre was briefly turned back into a 1920s movie cinema for a spot in the film *Driving Miss Daisy*.

In 1992, the edgy theatre received a $500,000 grant from the Lettie Pate Evans Fund administered by the Woodruff Foundation. Managing director Lisa Mount described the recognition given to the theatre as well as the unique relationship the theatre had with the neighborhood: "We've

moved from marginal to the brink of major recognition. Suddenly, we're the hip place to be. But that doesn't mean we want gentrification. We don't want to be another Virginia-Highland. We want to keep the special feeling of diversity and unpredictability that makes Little Five Points the most exciting neighborhood in Atlanta." Hamilton remarked on the award, saying, "It's a tribute to our tenacity—or foolhardiness, I sometimes think. It's a recognition of the viability of the whole Little Five Points community that supports us." Seven Stages is no doubt a perfect fit for the neighborhood, producing edgy, often shocking, yet thought-provoking plays. Seven Stages puts on plays in order to "further break down walls dividing cultures in Atlanta and around the world."[50] Personally, I would venture to say that a large number of people who congregate in Little Five Points do so because it is a place where the metaphorical walls dividing cultures are smaller than anywhere else in the city.

To detail all of the plays and musicals that have been shown at Seven Stages would require another fairly lengthy work. What seems to be constant is that there is no issue Seven Stages will not touch. For example, in 2003, the first Western staged reading of *Heaven Is Late*—an Iraqi play that was smuggled out of Iraq during the Hussein regime—took place at Seven Stages.

As John Sweet mentioned, there was a great emphasis placed on property ownership by those who spearheaded L5P's revitalization. Jordan and Bender subscribed to this same philosophy and honored the promise that they had made to Seven Stages allowing them to purchase the building.

Chapter 4
SMALL BUSINESSES IN A CORPORATE WORLD

What makes Little Five Points so fascinating is not just the element of "weird." One of its most fascinating features is the element of the small, independent businesses that have characterized L5P since the mid-1970s and have somehow continued to thrive in an era when almost every store and shop—even the small little boutique that you never thought would be—is corporately owned. What draws people to Little Five Points is the element of the individual, the small business without shareholders to appease—individual expression uncorrupted by the rules and regulations of corporate America. Even the name "Little Five Points" exemplifies this idea. Five Points in downtown Atlanta used to look like a little Manhattan, with all of its crowds, trolleys and massive corporate skyscrapers. Little Five Points sounds like its younger sibling, with its small, one-story, independently owned stores. During the 1970s, a few courageous entrepreneurs opened up shop in Little Five Points. Cheap rent and spirited redevelopers were enough to catch the eye of the founders of three stores: Wax n Facts, Stefan's Vintage Clothing and Charis Books & More. These three landmarks have paid their dues for more than thirty years in L5P and deserve recognition for taking the risk of settling in the once rough, downtrodden business district.

Harry DeMille opened his record store, Wax n Facts, on June 6, 1976. DeMille is slight in stature, with a mischievous, childlike grin and an unassuming demeanor that accentuates his dry wit. I asked him what the area was like when he moved in. "Oh, it was a total dump," he said with a grin. "It was just shy of going completely ghetto. Every fourth storefront

on Euclid and Moreland, almost invariably, was boarded up and had been for years."

DeMille describes himself as an "old hippie capitalist" and affirms that if the area had not been so run-down, he would not have been able to afford to open his shop. The original Wax n Facts was half the size that it is today, consisting only of the left side of the store as you walk in. The neighboring store in 1976 sold antique junk, according to DeMille. Cheap rent was not the only reason for Wax n Facts' location. DeMille, at the time, was living in L5P on Seminole Avenue. He does not believe that he was taking much of a business risk, since his initial monthly rent was only $110. His minimal risk began to slowly pay off in the early 1980s, part of which he attributes to the L5P Community Pub replacing the Redwood Lounge. DeMille believes that the pub was vital in removing the sinister atmosphere and creating a legitimate business atmosphere in the area.

DeMille's earliest customers were kids from the surrounding neighborhoods. "A lot of children of parents I knew from the neighborhood came in, but I never saw much of the parents," he explained. At the time, Bass High School was still operating, and a lot of students in the eighties punk scene patronized Wax n Facts. Mostly, DeMille attributes his success to word of mouth and the devotion that record collectors have to their collections. People come to Wax n Facts from all over the South in search of the ever-elusive rare record.[51] I know a few devoted record collectors—a unique breed. They will go to almost any lengths to find that one vinyl essential to their collection. DeMille and his staff know this and pride themselves on their wide range and knowledge of records from many different musical genres and eras. Wax n Facts does not bother with fancy signs or giveaways; rather, the store is decorated quite randomly, and records are often stored in old milk crates. Customer service and selection have made Wax n Facts one of the country's top independent record stores. In April 2009, *Spin* magazine rated Wax n Facts the fourth-best independent record store in America.

Stefan's Vintage Clothing arrived in L5P in 1977. Founded by Stefan Scott, this clothing store was another venture that would not have been located in L5P if the rent weren't so cheap. Rebecca Birdwhistell, Scott's former business partner, came onboard in 1980 and remembers the grittiness of L5P. "At the time, you couldn't just walk in our front door. If you wanted to come in, you had to buzz us from the front door and we would let you in. That shows you what the neighborhood was like then." Scott and Birdwhistell leased the building, which has three storefronts, with an option to buy. They cashed in on that option and purchased the three storefronts for just $50,000.

"We would never be able to afford a lease in Little Five Points now," added Birdwhistell. Stefan's now uses two storefronts for its store and rents the third. "At one point, half of the store was an art gallery. That made us no money. Then there was a leather shop in a little corner of the store which did not last long." In the 1970s and 1980s, vintage clothing was obviously not what it is now—clothing from the 1970s and 1980s—nor was it anywhere near as popular. Nowadays, opening a vintage clothing store is hardly considered a risky business venture, but in the 1970s, it most certainly was. "Vintage clothing is so much more mainstream now," said Birdwhistell. "Back then, it was a very rare group of people who were interested in dressing that way. We sold from the 1940s and 1950s, items like zoot suits."[52]

Stefan's Vintage Clothing is another example of a quality, independently owned business that once catered to a very specific type of individual. Now that vintage is mainstream, Stefan's does not stand out as innovative to the passerby, but for those who know its history it is a unique store that, thirty-three years ago, took the risk of opening in L5P and has become an area mainstay.

Charis Books & More is arguably the most unique bookstore in Atlanta. Founded in 1975 by Linda Bryant and Barbara Borgman, Charis is one of the few feminist bookstores remaining in the country. Bryant was just twenty-six when the store opened in the Point Center Building. "I was twenty-six, and I wanted to do something different," she said. "I was a schoolteacher for a minute and was frustrated with the system, but I still loved literature, books and bookstores. I felt a calling to make books available, and this came to me as a wonderful way to serve others."[53]

No business is more symbolic of the tolerant, independent streak characteristic of L5P. What a risk it must have been to open a feminist bookstore in the same vicinity as places like the Redwood Lounge. Yet Charis—which comes from the Greek word meaning "gift" or "grace"—is one of L5P's longest-running stores. Though it now specializes in feminist literature, Charis also stocks its shelves with works of spirituality, psychology, faith, politics, romance and "all the categories you see in a mainstream store," said co-owner Sara Luce Look. "It's just through a broad, feminist lens."[54]

Renowned authors Shay Youngblood and Pearl Cleage are two of the many authors who have given readings in the 1,200-square-foot store at 1189 Euclid Avenue. Youngblood was deeply worried in late 2005 when she received an e-mail notifying her that the bookstore that had helped launch her bestselling career was in dire straits. "Charis is like a home to me, so when I got the e-mail I panicked. The idea of it not being

there anymore is heartbreaking." The aforementioned e-mail was sent out to Charis patrons after years of decreasing sales. Things reached a breaking point in 2005, in large part due to the new Barnes & Noble that opened in the Edgewood Retail District. Charis supporters rallied around the store, and despite the corporate bookstore opening down the road, Charis pushed through its financial woes. Just as Wax n Facts caters to the record collector looking for that one elusive record, Charis is there for the disillusioned individual looking for that one book that speaks to her. These kinds of books cannot be found at Barnes & Noble. "We are a mission-driven bookstore," said Look. "People who feel marginalized find we have books that speak to them."[55]

Charis's arrival in L5P was not the start of the lesbian and feminist presence in the area. By 1971, Little Five Points was home to a growing lesbian and feminist community, many of whom had been involved in various other social justice movements (e.g., civil rights, workers rights and communist/socialist organizations, antiwar and anti-imperialism and the women's movement). On June 23, 1972, these women held the first ever Atlanta Lesbian Feminist Alliance (ALFA) meeting at the ALFA House at 1190 Mansfield Avenue. The alliance was formed, according to former ALFA member and *Bird* writer Lorraine Fontana, because "we need to organize ourselves; we need *not* to have to fight with these notions of sexism. We want a women's-only space— a *place* where women who come from other neighborhoods or outside of Atlanta…can come to just be with other lesbians."[56]

Another former member, Vicki Gabriner, was involved with the Atlanta Women's Liberation, which she found to be "too straight," and the Gay Liberation Front, which she found "too male." ALFA created a place where feminists could go to meet other women with similar views. ALFA supported feminist and lesbian rights by marching on Washington, fighting for equal rights for lesbian couples and protesting anti-gay laws. Though the organization only stayed at its original Mansfield Avenue location until October 1973—when it moved just east of L5P on McLendon Avenue and then into its own house on Kirkwood—it remained involved in the neighborhood. ALFA often attended or sponsored book and poetry readings and discussions at Charis Books & More. The first connection between ALFA and the WRFG radio station occurred when ALFA co-founder Elaine Kolb hosted the radio show *Lesbian Woman* in July 1973. In January 1982, ALFA members who were working at WRFG radio station helped form a women's radio group. In June of the next year, they marched with other lesbians from Candler Park to L5P in the Candlelight Lesbian Pride March.

ALFA was a very influential group in raising awareness about issues affecting the lesbian/feminist community in L5P and Atlanta as a whole. It also provided a place for lesbians to get together. They were extremely politically active, and they also threw parties, played sports and held many other social events, many of which were fundraisers for causes that they supported, including coalition work around race, class and disability issues. ALFA lasted from 1971 to 1994, when it sold its archives to Duke University.

Sevananda Natural Foods Market is the epitome of a community store. It is a cooperative business, meaning that members can buy shares in the company and receive a share of the store's profits as well as vote in board elections. In 1975, Sevananda was located in L5P, where the BOND Community Credit Union is now, in the Point Center building. When it moved to L5P, Sevananda was incorporated as a not-for-profit business under Georgia law, yet it was still a co-op. But instead of receiving store profits in return for membership, members received discounts on food purchases, as well as the right to vote in the board of directors elections and on bylaw changes and product policies.

The people who were moving into L5P at the time were extremely receptive to the communal-based philosophy employed at Sevananda, and the community co-op flourished. By 1984, the need to move into a larger space was evident, and Sevananda relocated to 1111 Euclid Avenue. Sevananda never wavered in terms of its products. It sells whole and organic foods and no red meat, poultry or fish of any kind; if it contains animal flesh, the store does not sell it.

Sevananda thrived in its Euclid Avenue location and, by 1993, had over one thousand members, over forty employees and working members of the co-op who received discounts as a result of their work. Senior, handicapped and low-income individuals also received member discounts. Educational classes were also being taught in an effort to educate both members and nonmembers on the benefits of healthy living.[57]

Because Georgia has no laws regarding consumer cooperatives, Sevananda reincorporated as a cooperative under the state of Wisconsin's co-op status on January 1, 1995. Now the store was legally a co-op and not a not-for-profit business and therefore able to offer shareholding members a percentage of the store's profits. By the late 1990s, Sevananda was established as one of the South's largest food co-ops and needed an even bigger space. In 1999, it moved from Euclid Avenue into the old Sharpe's Appliances building at 467 Moreland Avenue. As of 2009, the store building

is twenty-nine thousand square feet and is about as eco-friendly as a business building can be. Besides recycling cardboard, glass, plastic and office paper and repainting its walls with low VOC paint, which substantially cuts down on the emission of harmful toxins, the store has twenty-four solar panels on its roof, which substantially cut down energy consumption.[58] The L5P community has played such a major role in Sevananda's success that its cooperative relationship has sustained a store devoted solely to health foods for over thirty-five years. "There is just so much here and that is one of the things that is so amazing to people: that we can fill up a store this size with just vegetables and healthy foods and be successful," said Sevananda's general manager, Steve Cooke. "It's a testament to the community."[59]

Chapter 5

RADICAL MEDIA
Radio Free Georgia

The staple radio station in L5P is WRFG-FM (89.3), which today plays music of every genre and from every corner of the earth. I sat down with Harlon Joye, one of the station's founders and longtime DJ and board member, and he gave me a firsthand account of the station's history.

Joye is a seventies relic. When I spoke to him on the phone, I thought I was talking to Bootsy Collins. His voice sounds like that of a cool, 1970s hepcat and he wears a smooth, slightly upturned mustache that only he could pull off. He is also a wonderful storyteller. I went over to his house to ask him a few questions and then be on my way and ended up staying for two hours listening to him speak.

Originally from the South, Joye lived in New York City for nine years, which is where he discovered radio. After doing some documentary programming for WBAI in New York, he moved to Atlanta in 1966, found that there was not much of a radio scene and wanted to change that. "This guy from St. Louis, Jeremy Landsman with KDMA, and a guy out on the West Coast, Lorenzo Milam, realized that all the frequencies were being sucked up by institutions of one type or another: churches, colleges, and they wanted more independent community stations," Joye explained. "So they made up this whole plan and got permits from the FCC to build these stations in Charlotte, Atlanta, Birmingham, Tampa, New Orleans, Denver, Houston. And they sent people out to pioneer these stations."[60]

Joye did not care for Tom Connors, who was sent from St. Louis to develop the Atlanta station. According to Joye, no one else did either. "He thought

he was going to have a play toy," Joye told me, shaking his head. "I think they sent him down from St. Louis to get rid of him." By this time, there was a group of folks interested in creating a political radio station, including John and Beth Miller, who had spent time at the St. Louis radio station and were just as eager to be rid of Connors as Joye was. They had a meeting at which they decided that, even though he had an operating license, Connors had to go. "We finally forced this guy out...sent him on his way," Joye said with a smooth grin. He went on to tell me how they went about doing so. This is one of the eeriest stories I can imagine being a part of.

This guy comes over. He was the first black radio engineer in Atlanta, and he brings his son. His son has this little one- or two-block radio station in his neighborhood because his dad bought him this transmitter board. Anyways, his son really wants to get more involved with radio. The guy's [the son's] name was Wayne Williams, and Wayne had a high school group that got really involved with the station. At one point, we went down and had a meeting with one of the few FCC lawyers in Atlanta, Larry Lee, and told him about some of the things that were going on with Connors. Connors would show up at our houses during dinner and start banging on the table and screaming at us—it was getting really bad. It was really Wayne that swung this deal; Lee went to Connors and said, "Look here; I can pull your license. If you want to keep your license you'll pull out of town."

Unbeknownst to anyone at WRFG, their young friend and aspiring DJ, Wayne Williams, would soon be revealed as one of the most horrific serial killers the country had ever known. Between 1979 and 1981, at least twenty-nine young African Americans were killed. On June 21, 1981, Williams was arrested for the murders of twenty-seven-year-old Nathaniel Carter and twenty-nine-year-old Jimmy Payne. During his trial, the prosecution showed that Williams was a pedophile who hated and resented other African Americans. After he was convicted of the two murders and sentenced to life in prison, police closed the books on twenty-three of the twenty-nine remaining unsolved murders, and from then on Williams was known as the "Atlanta Child Murderer."

After Connors was gone, the station was left with few options. Joye continued:

So we had a permit to build a station, but none of us had any money. He [Connors] had come down with a foundation letter that said, "We will

grant the permit holders up to $10,000 to build a station." The key was "up to." They granted zero; they had no intention of granting any money, it was just a ploy. You see, if you have a foundation letter from the FCC saying, "We grant up to $10,000" then you have the backing the FCC requires to start a station.

Joye and his friends now had to decide where they were going to put the station, which was a difficult decision since they had no money. They thought of trying to raise some funds and open in Midtown, which was considered the "hippie" part of Atlanta. "Which was fine," according to Joye, "but several of us did not want the station to take on a hippie connotation. So I was walking up the street on Euclid and I saw a 'For Rent' sign at the building where El Myr is. I went in to talk to the owners; they had a contracting place in the front and wanted to rent out the backspace. Well, the back space was a dump. So we cut a deal with them and rented out the back space and that's where we first set up the station." Radio Free Georgia first went on air in mid-July 1973 at just eighteen watts. Eighteen watts would be okay if they were broadcasting in Kansas, where the highest point is a large anthill, but not in Atlanta. Meanwhile, Joye, his wife, Barbara, and the growing number of volunteers—including Reba Bolt (an ACLU attorney), Tim Hayes, Steve Wise and others—were trying to figure out how they wanted to put forth their left-wing message. They wanted to play all types of music, not just one genre, as is common with most radio stations. They also wanted a racially integrated station, which had not been the case until the arrival of Tim Hayes. "Around the *Great Speckled Bird*…was a guy named Tim Hayes who had been the Information Minister for the Black Panther Party here. We became friends with Tim, and Tim got involved with the station. We sat down with him and said, 'Look, we need to get some more black folks involved with the station.'" Hayes quickly recruited about four or five well-known individuals within the community, including Ebon Dooley and Paula Whatley, both of whom became board members. Next on the list was finding an engineer. Connors was the only one with a first-class engineer's license, and he was long gone.

The solution came in the person of Jim Tripp. "Jim was about as country as you can get," Joye said laughingly. "He learned a lot about the way you treat women and the way you treat blacks." With the pieces in place, Joye went about raising money—a task that proved arduous for WRFG throughout the years. "We rented out our signal from 10:00 a.m. to 6:00 p.m. every day to a fellow named George Butler. I had gotten in touch with

people I knew in New York and pulled in some money. And there were several gay women who lived across the street and one of them had inherited some money. Well, she didn't want inherited money; she wanted to give it to good causes, so we got what was at that time a substantial amount of money [about $3,000]." This money did not last long, and Joye eventually resigned as station manager at the end of 1973 after going twenty-six weeks without pay. His weekly pay amounted to only $50, but times were so tough that even such a small amount could not be spared, and for a short while the radio station ran on a solely volunteer basis, a violation of FCC regulations.

"And then CETA (Comprehensive Employment and Training Act of 1973) saved us. In the first CETA round we didn't get approved. In the second CETA round, we got approved for a five-person staff." This five-person staff allowed WRFG to upgrade its signal to 2,300 watts. WRFG also switched frequencies with Clark Atlanta University. "We switched frequencies with them because our frequency was a closed frequency; it was blocked and Clark's was open, but Clark wasn't looking for that. They were thinking of it as a university entity not a broad entity." For a few years, WRFG even broadcast from the Clark Atlanta radio tower.

Finally, by 1974, WRFG was on stable financial footing. Internally, however, the station was having its difficulties. As Joye said, "We were trying to be so damn democratic that we were changing board members every chance we had. And the FCC does not look kindly on that. The board owns the station, and they [FCC] want to make sure the ownership is stable. So our lawyers got in touch with us and said, 'You can't keep doing this.'" The FCC requires that every time there is a 50 percent change on the board, the station must file for a change of ownership. The lawyers decided that they were not going to file for a new ownership and that the board as it was in 1974 was how it would stay for the time being. "'Your board right now consists of Larry Lee, Harlon Joye, John Miller,' and he went through the board and said, 'That's your board and you're going to keep it for now!'" Joye explained the brief but emphatic demand from WRFG lawyers. That is the story of how Joye went back on the board.

This ultimatum sparked an interest within the radio station to set up some rules as to how board members would henceforth be elected. Members of the board are nominated by three groups: other board members select one-third of the nominees, community members and community organizations select one-third of the nominees and volunteer staff select one-third of the nominees. This system allows all the facets of the station, including listeners, to have a say in who is on the board. Board

members have the final say in who is elected, thus ensuring the proper cultural mix that WRFG so values.

In 1977, WRFG was given permission to broadcast at three thousand watts. It signed a contract with WQXI (channel 11) to carry the WRFG frequency on its antenna. This was a major victory for the station, which could now reach a substantial audience and seriously increase its fundraising base. Unfortunately, there were still elements in the Atlanta Police Department dedicated to preventing the "lunatic fringe," i.e., alleged Communists, from infiltrating the community. And there were individuals seeking to boost their careers by snuffing out any sort of so-called "subversive element" within the community. Upon hearing that the little radio station in L5P was expanding, John Inman, head of APD Subversive Control Unit, went on the offensive against WRFG, which he claimed was run by "Trotskyites, Communist Party members, Weathermen, homosexuals, Black Panthers and dope-smokers."[61] Inman went to channel 11 and persuaded them to revoke WRFG's contract. Lee, WRFG board member and attorney, sued channel 11 and received $30,000 from the station, about $12,000 of which was ultimately secured.

The following excerpt comes from a 1993 interview with Joye, in which he describes the "Red-baiting."

This was the time when the Atlanta Police Department had a list of the ten most dangerous radical "hives of activity" in the city, and one of them was the "Peoples Place" in Little Five Points. The Red Squad called their attorney, who happened to be in the same firm as our attorney. Because of that, we knew what the Red Squad was saying about WRFG as well. We taped what our attorney said about this. The tape later disappeared. Larry [Lee] will tell you that at one point he was at an Episcopal charity and the guard was a former member of the Red Squad. In the conversation, WRFG came up and he said, "Ya'll wouldn't have any trouble if you got rid of Harlon Joye." He said they had an affidavit from Tom Connors saying that I was a known dope dealer on the strip and carried a pistol at all times. That scared the shit out of me. We had a robbery at our house one time that I knew was related to this. What the fellow was looking for by going through my desk drawers indicated it was not a normal theft. There were some strange things going on then.[62]

When the short-lived relationship with WQXI ended, WFRG bought a twenty-five-foot tower and set it up outside, behind its little office in the

back of 1091 Euclid. Joye was back at it, looking for ways to raise money. He explained:

> *I made up a list of possible programming conceptions that might be fundable. Michael Lomax at the time was head of cultural affairs for the City of Atlanta. Michael said, "I got a guy here named Jack Bagleonski. Why don't you go talk to Jack?" So I went and talked to Jack, and I had an idea for a series of oral histories on the city of Atlanta, which he thought the National Endowment for the Humanities would like. He helped me write a grant proposal for the National Endowment for the Humanities.*

The NEH liked what they saw and asked Joye to do a pilot, giving WRFG $23,000 in 1978 for that purpose. Joye hired two consultants: George Mitchell, a photographer who had created a history of Ponce de Leon Avenue, as well as many other historic projects; and Bernard West, a history professor from Clark Atlanta. "They [NEH] wanted us to do two programs and we did five—three on the history of railroads in Atlanta and two on the history of Clark Atlanta." The program was a huge success. "We sent them off to the NEH, and the NEH funded us for $78,000. Then I hired Bernard full time and Cliff Kuhn [who also had a history doctorate from Clark], and we did fifty-two programs. We did fifty half-hour programs and then we got money from Georgia Endowment for the Humanities to do one on the 1906 race riots and one on the lynching of Leo Frank. The fifty went from World War I to World War II."

These programs, called *Living Atlanta*, brought in both money and volunteers. About 10 percent of the grant money went directly to the station, and about 250 people came in as volunteers after hearing the programs. The series won awards from the National Federation of Community Broadcasters (NFCB) for the sections on railroad workers. Finally, Joye, Kuhn and West teamed up again to write the *Living Atlanta* book, published by the University of Georgia Press.

In 1982, WRFG moved into its current location in the L5P Community Center. By this time, WRFG had made a name for itself, largely because of Joye's *Living Atlanta* series, as well as its mission to appeal to all classes and races. WRFG was the first station in Atlanta to play music for the growing Hispanic and Asian communities. It also introduced what has proven to be one of its most popular programs, *Good Morning Blues*, which runs from 6:00 to 10:00 a.m. Monday through Friday. The blues has also brought in the green. According to Joye, "Some of our biggest donations come from our

blues fans. Two of our programs—Faye Dunally and Ernesto Pérez—both of them had aimed programs at prisoners in the federal pen."

This turned out to be especially noteworthy in 1987 during the Atlanta prison riots. On November 20, 1987, the U.S. State Department announced that American diplomats had signed an agreement with Cuba, which called for the repatriation of over 2,500 Cuban émigrés.[63] On November 23, tensions exploded in Atlanta's federal pen, which housed approximately 1,400 Cubans. Over the next eleven days, 89 hostages were taken and over $35 million in damages were done to the Atlanta prison. On December 3, a tentative agreement was reached with the rioters that called for "a moratorium on deportations and a fresh round of hearings for all 3,800 detainees in federal custody."[64] During the standoff, the city, as well as the tumultuous prison, tuned in to WRFG, which was the only station the Cubans would communicate with. Pérez had been taking calls from detainees and their friends and families and also allowed Gary Leshaw, an attorney for Atlanta Legal Aid, to ask for a release of hostages as a show of good faith. During the eleven-day standoff, no guards or prisoners were hurt, largely due to WRFG's commitment to keeping the lines of communication open between the prisoners and their families and friends on the outside. The riots actually turned out well for the Cubans, since many of those who did not pose a threat to the public were released. In the aftermath, WRFG continued to serve as a voice for the free Cubans. One caller, in December 1987, called in to Pérez's show, *With a Cuban Taste*, and explained, "Some brothers have been called to be interviewed who have their release date—their papers for freedom."[65]

In the early nineties, the station was looking to power up. Since 1980, it had been broadcasting at 24,000 watts. In 1993, its twentieth year on air, the station was granted permission by the FCC to upgrade to 100,000 watts. Yet in order to make this monumental upgrade, the station needed $200,000 in addition to its yearly $125,000 budget. Numerous fundraisers—concerts, auctions and membership drives—took place over the next few years, and finally in 1995, WRFG reached another goal, broadcasting at 100,000 watts.

Throughout the station's history, raising money has been an ongoing struggle. When I first visited the modest office in the L5P Community Center, I patiently waited to speak to a female volunteer for about ten minutes while she arranged for a WRFG supporter to bring his pressure washer to a carwash fundraiser. You are not going to hear WRFG giving away $10,000 at 10:00 a.m. or using any other sort of gimmick to attract

listeners. What you will find is the most diverse mix of music on Atlanta radio, experienced and knowledgeable DJs who love music (Joye has a collection of over six thousand records) and left-wing politics that follow in the mold of the *Great Speckled Bird*.

Recently, two of WRFG's most popular and longtime personalities passed away. Ebon Dooley, born Leon Thomas Hale, was one of WRFG's first African American personalities. A graduate of Columbia Law School and a published poet, Dooley arrived at WRFG in 1973 and brought with him a politically progressive mentality and a love for jazz. Working at WRFG did not pay that well, but it allowed the activist, in his own words, "to make the radio accessible to people who are traditionally denied access to commercial radio, whether it's due to unpopular views, ethnicity, sexual preference, whatever."[66] Dooley died of a heart attack at his Stone Mountain home in October 2006.

Robert "Joe" Shifalo also joined WRFG in 1973 and was the man who started the *Good Morning Blues* program. Like Dooley, he had a law degree, which he earned from John Marshall Law School before joining Economic Opportunity Atlanta. Shifalo was a musician as well as a DJ and recorded two albums and six CDs during his lifetime. He also persuaded the Atlanta Board of Education to rent to him the abandoned Moreland School building, which he eventually turned into the L5P Community Center. Incredibly influential to WRFG and L5P as a whole, Shifalo suffered a fatal heart attack at his Atlanta home in March 2009.[67]

The *Great Speckled Bird* relocated to L5P from its old location on Juniper Street in 1976, shortly before publishing its last issue.[68] The newspaper's name came from the title of an old Roy Acuff song that was based on the Bible verse, "Mine heritage is unto me as a speckled bird, the birds round about are against her; come ye, assemble all the beasts of the field, come to devour" (Jeremiah 12:9). The paper was part of L5P in a much deeper way long before its headquarters moved into the area. WRFG initially modeled its "free-form" left-wing, anti-Vietnam message after the *Bird*. The president of WRFG's board of directors, Heather Gray, said, "WRFG grew out of the movement of the late 1960s and early 1970s. The early founders could have started a newspaper, but they chose instead to create a radio station." They did so, in large part, because the *Bird* was already established as Atlanta's premier radical newspaper. Rather, WRFG emerged as the radio outlet to "implement ideas" on the same "wavelength" as the *Bird*. Harlon Joye credits the newspaper as being instrumental in helping with the founding of WRFG, and it was a 1973 *Great Speckled Bird* article that announced the opening of

the new radio station broadcasting out of L5P. In fact, Joye's wife, Barbara, was on staff at the *Bird*. Other *Bird* staff worked with WRFG and vice versa to provide a progressive, left-wing radical voice in the Deep South.

The forerunner to the *Bird* was the *Emory Herald-Tribune*, a weekly anti-Vietnam War newsletter circulated on the Emory University campus. The first issue of the *Bird* hit the streets on March 8, 1968. It smacked the left-wing minority of Atlanta in the face, and they liked it. The *Bird* soon became so popular among progressive liberals in the Gate City that it went from being a biweekly publication to a weekly newspaper. Unlike other underground newspapers that focused solely on politics, the *Bird* attracted readers with a full spread on the liberal, counterculture lifestyle of the time, including concert and book reviews, along with articles on antiwar protests, women's liberation, racism and so on.

As was the case with WRFG before the FCC stepped in and forced it to stop the revolving door of board members, the *Bird* practiced a similar leadership technique, rotating the different editorial positions on a fairly regular basis. And like WRFG, volunteer commitments were critical, as passionate readers often served as distributors, selling copies of the newspaper in schools, on college campuses and on the street.

Many of the articles from the first three years of the *Bird* were about national and international issues, as well as personal stories of the staff's being harassed by the police. However, starting in 1972, the *Bird* began placing more emphasis on local issues and events, such as the Stone Mountain Tollway battle. No matter what they were writing about, the writers for the *Bird* never beat around the bush. The paper was gaining more and more popularity throughout the city and even grabbed some national attention when CBS's Mike Wallace referred to it as "the Wall Street Journal of the underground press." And just like WRFG, it was rubbing Atlanta's brass the wrong way. The *Bird* catered to the "wide-eyed radicals" in L5P at the time. It was there to guide and support WRFG in its efforts to carry on its socially progressive message. It was there to fight alongside L5P's pioneer redevelopers against the Tollway and to celebrate with them when they won.

Chapter 6
RACISM, SKINHEADS AND DEATH

During the revitalization of Little Five Points in the late seventies and early eighties, the "regulars" who owned shops and patronized the area were mostly former hippies—peace-loving folks, disillusioned with the fast-paced, no-holds-barred, corporate America. But in the mid-eighties, a new emerging sect of disillusioned youth began creeping into Little Five. They called themselves "skinheads," or "skins" for short, and modeled their dress and attitude after the original skinheads of Britain's working class in the 1960s. Dressed in knee-high Doc Marten boots and sporting swastika tattoos along with shaved heads, the skins hung out in Little Five, drinking beer and often shooting their mouths off at anyone who did not look like them.

When they first showed up in Little Five, many people did not know what to think of them. *Are they dangerous or are they pure shock value?* It appears that they were a little bit of both. I find them to be somewhat contradictory. They dressed in Nazi regalia yet they had black members and were vehemently pro-American. It appears that, for the most part, they were just a bunch of bored kids, searching for an identity, who liked to get drunk and shock people. There were a few exceptions, however. Four skins from L5P were charged in the brutal beating of 686 Club owner John Wicker on December 16, 1985. Allegedly, after being kicked out of the Spring Street club, the four skins brutally beat Wicker with a lead pipe, resulting in a trip to the hospital for the club owner and more than one hundred stitches in his head.[69]

The Atlantans in Defense of Democracy (ADD) became active in L5P to combat the skinhead nuisance. The skins perpetrated a symbolic act

of violence when they defaced the seventy-one-foot-wide Peace Mural on Seminole Avenue, covering the collage of civil rights and anti-nuclear movement pictures with numerous swastikas and the initials SWP, which is believed to stand for "Supreme White Power." L5P is, as Richard Shapiro (the L5P dentist of whom much more will be spoken) calls it, "the most tolerant place south of Greenwich Village and east of Haight-Ashbury. If you're not tolerated here, maybe you're just not tolerable." Such became the case with the skinheads. Representatives from ADD and other anti-fascist organizations held a rally dubbed "Restore the Mural/Rock for Your Rights" in early July 1986, which featured numerous bands and speakers.[70]

The skinhead violence and vandalism began to subside, and the skins even won over some L5P locals as the most outspoken opponents of a KKK rally. The Klan made a cameo appearance in L5P, not to make a fashion statement but to protest an anti-KKK musical called *Bang Bang Über Allies* playing at Seven Stages.[71] The skins saw the formidable crowd of anti-Klan protestors jeering the Klan and joined in. There were still spotty episodes of violence and anti-Semitism that were attributed to skins, but all in all, the skins who congregated in L5P seemed to get the message. Then, in 1988, the murder of a skinhead, Denise Damron, led to the death of a heroic Atlanta police officer who, through his tireless devotion to justice, is immortalized in Little Five Points history.

My knowledge of Denise Damron comes from a 1988 *Atlanta Journal-Constitution* article. Damron ran away from her parents before she began hanging out with the skins in Little Five Points. Her parents had dealt with this before and had even sent her to a psychiatric hospital. They had reached the point where they would rather know where she was and let her be than have her go into hiding. Ever since she began hanging out with the skins, she had seemed to be genuinely happy for the first time in her life. Yet her parents still feared that one day they would pick up the phone and the police would be on the other end of the line, telling them that their daughter had been "raped, beaten or killed." Their worst fears came true early Tuesday morning, August 23, 1988. Damron was with a group of her skinhead friends, gathered in their usual spot outside of the Point, when a tall, black male riding a red bicycle approached her. From here, details are vague, but witnesses told police that the man said something to her, whereupon she told him, in so many words, to get away from her and then shouted an ethnic slur at the man. Following the verbal altercation, the man began chasing her down on his bike. Damron was said to have "freaked out" and started running from the man down Seminole Avenue. Her assailant fatally shot the

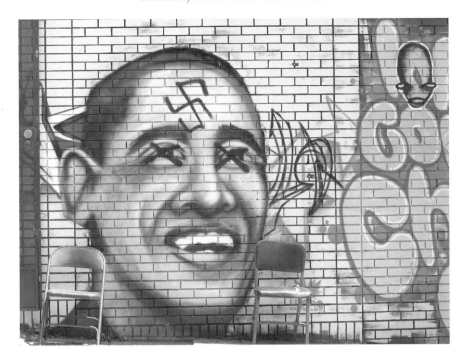

Though racism in L5P is far less blatant than in the skinhead days, sporadic episodes still occur, such as the defacement of a President Obama mural in May 2008. *Photo credit: Joeff Davis/www.Joeff.com.*

teenager just three doors down from where she lived with her boyfriend. "I heard the shot but didn't realize what it was. I heard the shot that killed her, I was probably only twenty-five yards away," said her boyfriend, Ed Collins, breaking into tears. "She was adorable, she was a beautiful, beautiful person. She didn't deserve to die that way."[72]

Gregory L. Davis was an African American Vietnam veteran and seven-year veteran of the Atlanta Police Department. He was off duty early morning Friday, August 26, 1988—just three days after the slaying of Denise Damron—when he got a phone call telling him that the cat burglar he was chasing had been spotted in the Lake Claire neighborhood, just outside of Little Five Points.[73] Davis had been working a burglary detail in the neighborhood, which had been terrorized by a black male cat burglar on a red bicycle who matched the description of Damron's killer. Davis and another off-duty officer both responded to the call in separate cars. Davis reached Sutherland Terrace first and, after spotting the suspect, allegedly pulled his car alongside him and asked him to pull over. According to Lieutenant Horace Walker, Davis stopped his car and got out. Upon

doing so, he was hit in the chest with a bullet from a .38-caliber handgun belonging to twenty-three-year-old Timothy Riley. Though Davis had just been mortally wounded, he managed to duck behind his car and fire four shots, one of which hit Riley in the head,[74] before radioing in, "I've been shot. I've been shot."[75]

Within two minutes, backup arrived and found both men—the hero and the killer—dead from a single gunshot wound each. There was an intense outpouring of support for the slain officer from both the law enforcement community and the folks in Little 5, one of the areas that Davis patrolled. It is common when someone dies for the deceased's friends, family and associates to shower him with praise and forget about his faults. But everyone who remembered the fallen officer said the same thing: that he deeply cared about people. He was not an officer who was hasty to arrest someone without a sense of certainty of their guilt, and when he did make an arrest, he spent his time not talking down to the prisoner but making a sincere effort to counsel him or her on better ways to live. "He made good cases," said Atlanta public defender Harry S. Gardner. "He wouldn't arrest someone without probable cause, and he was just a great person." Major Lovett Goss, Davis's commanding officer in Zone 6, said of Davis, "There's no question he would have brought him [Riley] back here and told him about the importance of getting an education and a part-time job. Unlike most every other officer, he always found the time to counsel the people he was putting in jail."[76]

Just two weeks after Davis was killed, the L5P Business Association (L5PBA) announced plans to rename Seminole Plaza—bounded by Moreland, Seminole and Euclid Avenues—Davis Plaza in honor of the fallen officer. Davis Plaza was the first place in Atlanta named after a fallen officer, which, as then L5PBA president Richard Shapiro noted, "was very ironic, considering it's in Little Five Points." Ten years later, Shapiro, then admittedly not very active in the L5PBA, organized a stirring ten-year memorial of Davis's death. I spoke with Shapiro, who described the event and how he organized it. He said:

> I've had one major mitzvah in my life. A deputy chief of police at the time told me that the tenth anniversary of Officer Davis's death was coming up, and he asked me if we would be willing to put on a memorial service for him. I knew Officer Davis and he was a very nice guy, a super-nice guy—everybody liked him. So we did it. We closed off the Plaza and we had a couple hundred people there, maybe a hundred police officers, the

chief of police, some deputy chiefs, Davis's old partner, the mayor, Davis's family. There was the full honor guard, the riderless horse with the boots in backward, the bagpiper in a kilt playing "Amazing Grace." It was this wonderful memorial service to this fallen officer."[77]

Ginger Lyon, who attended the service, told me, "Richard [Shapiro] did a lot of great things, but I think that may have been his finest hour."[78] The memorial was also the first of its kind in the city's history. Little Five Points now had the first area named after a slain police officer and had carried out the first anniversary service of an officer's death in Atlanta. Furthermore, the L5PBA created and sponsored the Gregory L. Davis Award, a quarterly award given to an officer for outstanding performance in the Atlanta Bureau of Police Services Zone 6, which Davis patrolled with such distinction.[79]

In 1995, Zone 6 commander Carlos Banda claimed that most of the crime in Little Five Points was burglary, especially residential burglary, car theft and theft from cars.[80] Drug sales also came to light as a result of a July 23 shooting in that year. The shooting occurred on a Sunday night at approximately 10:30 p.m., when thirty-year-old Fred Newbaum opened fire on twenty-eight-year-old Robert Desmond and sixteen-year-old Tim Garrett inside Fellini's pizzeria on Seminole Avenue. The two victims were presumed members of the Bubble Gum Gang, a street gang composed of between ten and twelve members, most of whom were in their early teens, that hung around Little Five and was suspected of some neighborhood robberies and assaults on homeless people.[81] Newbaum's beef with the gang members stemmed from his certainty that they were selling crack-cocaine in the neighborhood. Atlanta Police Department sergeant Dan Genson said that Newbaum was fanatically opposed to drugs being sold in the area. Sergeant Genson also said that Newbaum did not intend to shoot Garrett, just Desmond, but would have kept firing had his gun not jammed. After the assault, Newbaum waited outside the restaurant for the police to arrive. Neither victim's wounds were fatal, and Newbaum was charged with two counts of aggravated assault.

In the wake of the shooting, members of the Neighborhood Planning Unit N (NPU-N) created a committee, made up of members from Inman Park, Candler Park and the L5PBA, to study crime in the area as well as do a little damage control. Zone 6 commander Banda assigned more bike and foot patrols for Little Five, but the discussion when the neighborhood group met with Banda and other officials at city hall was mostly about public

relations. Inman Park resident and NPU-N chairperson Bill Dorn said, "The conditions there [in L5P] have been changing over the last two or three years. It's grown with the neighborhoods, and a lot of it is just a function of use. We need to address the management of it."

"From both the public safety and the public perception standpoint, it's the same problem we have everywhere," Councilwoman Debbi Starnes added. "We have some actual crime and a worse perception of crime. It's a unique area of the city, and I think we need to put our heads together—see how we can keep the fabulous mystique of Little Five Points."[82] The conclusion reached by most parties involved was that Little Five was a fairly peaceful place, and the shooting was an aberration; yet as the area continued to grow in popularity, steps needed to be taken in terms of public safety.

In April 1998, a child was kidnapped from the China 5 Restaurant in Little Five. Barbara Higgins and her two-year-old daughter Destiny were waiting for Higgins's boyfriend, a cook at China 5, to finish his shift. A woman, known as a regular at the restaurant, approached Destiny and began complimenting her on her beauty. When the woman gave Destiny an apple and the toddler dropped it and began crying, the woman, known to the employees at China 5 as LaToya, offered to take her to a nearby fruit stand to replace the apple. Higgins, seeing no harm in the matter, allowed the stranger to walk away with her daughter. When they never returned, a distraught Higgins called the police and reported the kidnapping.[83] Luckily, the girl was found a week later, and her kidnapper was arrested.

It was about this time that Richard Shapiro was in negotiations with the city to install a police mini-precinct in Little Five. Shapiro is quite an interesting character. A Brooklyn native, Shapiro graduated from Emory Dental School about the same time that Kelly Jordan bought the Point Center building. Jordan wanted to add medical offices back onto the second floor, including dentistry. "I remember calling this dental supply company that set all the new dentists up with jobs," said Jordan. "So I asked them, 'Do you have anybody out of the ordinary?' And the guy said, 'Yeah, as a matter of fact, I've got this guy coming out of Emory Dental who's from Coney Island.' That's how I met Richard." Shapiro said of the Point Center building, "When I first saw it, there were holes in the ceiling, there were squatters living in the basement and rain was leaking in. I loved it."

Shapiro has remained in the neighborhood since 1978, not just as the "Little Five Points dentist" but also as a dedicated neighborhood activist.

He described his efforts to form the mini-precinct to me in a September 2009 interview.

> *Around that time, as president, I became very involved with the business association, and one of the issues that always came up was crime. One of the things that I was always asking for was for the police to get some timely and reasonable crime reports to the community, thinking that if people knew that a crime had just occurred a couple of hours ago they could be helpful in solving the crime, rather than finding out that a crime occurred a few days ago, or never finding out at all. The way that people got their information at the time was that they had to go down to the precinct and leaf through pages and pages of incident reports and then have to hand write the incident reports. I worked very closely with the head of Zone 6 at the time, named Major Banda, and he told me to call the computer guy at the station. I asked him if there was any way he could just send us the reports. At first he said that it shouldn't be a problem, but when I called back a few days later he said I needed approval from the chief of police.*

Shapiro paused at this point and laughed, wondering, as I was, why such a level of micromanagement was needed for these reports, which should be public record. He continued:

> *So I called the chief of police and set up an appointment to discuss crime statistics. Major Banda and myself went down and met with her and talked for a few hours. We had a fairly substantive conversation. Two days before the meeting, I downloaded about two hundred pages of research from their website about community policing. So when I went to the meeting, I said, "Everything I've learned about community policing, you taught me. I'm on board, let's do this, let's get some foot patrol officers out here, let's get the crime statistics—this makes perfect sense." Now I had also got kind of friendly with Deputy Chief Louis Arcangeli. He was a guy from the neighborhood and he had given me some tips on basic crime prevention.*

Shapiro broke into a smile and, half laughing, said: "What I didn't know was that he and the chief of police were in a big fight, which was about to go public, over crime statistics. So here I am in the middle, Mr. Innocent!" His persistence made a great impression on the chief of police, who called him back two days after their meeting.

*She said that she was willing to open a mini-precinct in Little Five Points
and staff it with foot patrols. It was a public-private partnership, with
the community funding the rent for the space and its cleanup and the city
providing the equipment and the officers. So, I'm the happiest guy in the
world, and I forgot all about the crime statistics. You know, when you
ask your dad for some wheel covers and he buys you a car, you don't go to
him and say, "Where are the wheel covers?" Later, the stuff hit the fan
about the crime statistics, and it was a huge scandal, but it worked out
very well for us.*[84]

Shapiro got to work raising funds from local businesses and the Inman
Park Neighborhood Association and the Candler Park Neighborhood
Organization. He asked for a twenty-five-dollar donation per household,
which would be refunded if the mini-precinct failed to come to fruition.
Such was not the case, and the mini-precinct officially opened its doors on
Davis Plaza in July 1999.

There is little doubt that without the presence of the mini-precinct, two
African American brothers would have lost their lives in April 2002. Che
and Idris Golden, twenty-nine and twenty-six, respectively, were enjoying
an early April day in Little Five when three overly aggressive panhandlers
approached them. After the Golden brothers repeatedly refused to oblige
the panhandlers, witnesses say that Christopher Botts, twenty-six, and
Angela Piscotta, nineteen, began punching Idris until he hit the ground.
As they began to stomp on him, Ulysses Adrande, twenty-eight, attacked
Che. Dozens of shocked witnesses stood by as this happened, and it is fairly
certain that the attackers were not about to let up. Thankfully, police from
the mini-precinct arrived on the scene and subdued the attackers, saving the
two brothers' lives. All the work that was put into funding and developing
the mini-precinct was worth it if the officers did nothing else but save these
two young men's lives.

Idris took the worst of the beating, spending six days in the hospital
recovering from his wounds. The attack was the first hate crime case
prosecuted in Fulton County's history. Ironically, it occurred in Little Five
Points, an area known for its racial tolerance. Yet it was the same tolerant
attitude that allowed the three attackers to panhandle without any risk
of being arrested, and they took advantage of it by committing such a
hateful act. Witnesses and the arresting officers claimed that Botts and
Piscotta (but not Adrande) were screaming racial slurs at their victims.
Maurice Geurin, one of the officers who arrived on the scene, testified

at trial that Botts said that "blacks are the reason for the downfall of our society."[85] Botts's attorney argued that the crime was not racially motivated because Botts had committed an almost identical assault on his own father several years prior. He was convicted of committing a hate crime, however, which added five years to his sentence. The other two pleaded guilty to aggravated assault charges.

Violence was not the only reason that Shapiro pushed so hard for the mini-precinct. The attack on the Golden brothers also fueled a debate that had begun many years before and continues today. What, if anything, should be done about the number of homeless and runaways who flock to Little Five Points seeking similar free spirits or a helping hand? As Shapiro says of Little Five, "We are a product of our own success," meaning that as L5P grew in mainstream popularity, the panhandlers and street people in L5P became more disconcerting to many shop owners who felt that they scared away potential customers. When L5P was still a rough area of town, the homeless and runaways were not as much of a threat to business because the type of people who patronized L5P were mostly blue-collar folks who were not taken aback by that type of people. When Inman Park and Candler Park were revitalized, wealthier people began to move in. These people are generally not comfortable living down the road from homeless people, many of whom are alcoholics and addicts. On the other side of the coin, the mystique of L5P has also grown, not just through Atlanta but through the entire Southeast, and therefore it has become more of a Mecca for the homeless and runaways. As Coyote Trading Company employee and longtime L5P regular Jack Weyler told me, "We probably have even more bums and runaways here now than ever because the word's gotten out. If you run away in the South, come to Little Five Points, hang out in the street and be a gutter punk."

It is important to note that some business owners, most notably Evelyn Barr, opposed the creation of a public plaza precisely for this reason. Barr repeatedly told the redevelopers that if they replaced Seminole Avenue with a plaza, all the "winos" in Atlanta would show up there. She led the opposition on the grounds that these winos would lurk around the plaza, drink Mad Dog 20/20 all day and harass customers. To a certain extent, she was right. The public plazas in L5P are certainly home to a lot of homeless drug addicts and alcoholics, some of whom harass pedestrians, but most of whom are peaceful. Davis Plaza provides outdoor seating for restaurants and coffee shops and is less frequented by the homeless than Findley Plaza. They both have trees and flower beds that are occasionally used as sleeping beds as well. Findley Plaza is

L5P residents put up Christmas trees in the mid-1970s where Findley Plaza is now. Passavant made the star at the top of the tree in the foreground out of a brush that city workers used to sweep the streets. *Courtesy of Reid Jenkins (www.freejoye.com).*

a gathering place for the homeless as well as for shoppers and occasionally for tired cyclists. The plazas are a tradeoff as well as a hot topic for debate.

I did a lot of research on the contrast between L5P and the two neighborhoods that sandwich it and the debate over the homeless, runaways and panhandlers. In the November 1996 issue of the *Inman Park Advocator*, Lori Feig-Sandoval contributed an article entitled "Five Little Points Make a Big Difference." In this article, Feig-Sandoval elaborates on how tired she is of L5P, specifically Findley and Davis Plazas, being occupied by drunks, panhandlers, addicts and others who "break the law in plain view every day and get away with it." She uses alliteration to describe five points that she feels L5P has an abundance of: litter, loitering, licentious behavior, a laxity of law enforcement (this article was written before the mini-precinct opened) and lack of community action. The concerned Inman Park resident called for a new attitude concerning Little Five—one that does not tolerate any sort of illegal behavior. She was not just against drug abuse and public drunkenness but also loitering and sleeping in public flower beds.

Feig-Sandoval is at one end of a very broad spectrum. If she represents one side of this issue, the late Kerry Wendell Thornley, probably L5P's most famous resident, represented the other. Before the rest of the world

came to know Lee Harvey Oswald as JFK's killer, he was Thornley's friend. They met in 1959 while serving in the U.S. Marine Corps together. Oswald's fascination with Communism and subsequent defection to Russia was the inspiration for Thornley's first book, *The Idle Warriors*. The book was not published until 1991 because the Warren Commission seized it as evidence after Kennedy's death.

L5P was Thornley's hip ghetto beginning in 1969. It was here that he wrote his classic religious satire, *The Principia Discordia*. Ho Chi Zen (one of his many pseudonyms) lived most of his life in accordance with his "Discordian" philosophy, which purports that any attempt to impress order on the universe is futile since life is governed solely by chaos. He wrote articles for the *Great Speckled Bird* and self-published a slew of novels that he passed around L5P. On November 28, 1998, Omar Khayyam Ravenhurst (another Thornley pseudonym) died of cardiac arrest after suffering from an autoimmune disorder. In his later years, Thornley was sure that his former pal Oswald had been a CIA agent sent to weed out any Communist sympathizers in the Marine Corps.

Protective of the environment that he fostered in L5P, Thornley blasted what he calls Feig-Sandoval's "touching display of class solidarity." He surmised that the reason there are so many drunks in the plaza is because the owners of the Chevron convenience store "sell the cheapest rotgut on the market." Furthermore, Thornley saw two Inman Parks. "There is the Inman Park of Lori's article, which includes L5P, and there is also the Inman Park of the Inman Park Festival—in which L5P was specifically denied permission to participate, thanks to Bill Dorn's [chairperson of NPU-N] pull with the mayor. Reality being what most of us suspect it is, however, there is no way outside meaningless technicalities that anyone can seriously claim L5P for Inman Park. Kuwait is much sooner a part of Iraq." Thornley was genuinely put off that Feig-Sandoval considered L5P a part of Inman Park, and he believed that Inman Park was a suburb for wealthy conformists who are far too concerned with upping their financial and social status to have even a clue as to what really goes on in the "hip ghetto" of L5P.

Panhandling, according to Thornley, is prototypical of any hip ghetto, and he suggests that Feig-Sandoval "just say 'no' if [she is] too stingy to give a quarter to a bum." Thornley went on to question: "Why carp for the rest of your pathetic life about being asked? If a beggar's plea is for you a traumatic experience, you don't belong in the big city."

Thornley was proud to live in an area that he saw as an "asylum for misfits, a refuge for people who don't watch television, don't talk about sports and don't

believe the awful lies that are told about marijuana." In essence, Thornley saw Inman Park and its residents as emblematic of the establishment of which he wanted no part. He seemed to relish the spirit of debate but had no tolerance for the upwardly mobile Inman Park crowd bringing its uptight and stuffy morals into an area where counterculture reigns supreme.

A homeless man in L5P tries to stay warm before nightfall. L5P "street journalist" Ebrima Ba explained this photo to me, saying, "He's right next to a phone but he has no one to call. The world has left him behind. He's been forgotten." *Photo by Ebrima Ba.*

Another contributor to the *Advocator* debates was Dawn O'Dell. Ms. O'Dell produced a response to Feig-Sandoval that seemed to encapsulate the middle ground of the argument. In a much more civil tone than Thornley's, O'Dell offered a viewpoint that centered on tradeoffs. She called the plazas of L5P the "most vibrant in the city" and asked Feig-Sandoval: "Where else in the

city do drum-circles and poetry readings occur out of thin air?" O'Dell believed that there is a certain tradeoff between the licentiousness and the free-spirited atmosphere of L5P. The freedom that affords such diversity and spontaneity often attracts an antisocial and disillusioned element.

One important aspect touched upon in the course of this debate was public alcohol consumption. As I mentioned before, many of the homeless and runaways in L5P, and everywhere else for that matter, suffer from alcoholism and addiction. Before the mini-precinct was created, the Chevron on the corner of Moreland and Euclid had been under fire from many community leaders for selling alcohol to impaired individuals. Thornley touched on the issue in his response to Feig-Sandoval, but Taylor F. Binkley, head of the Little Five Points Community Association (L5PCA), focused solely on public drunkenness as the source of the behavior that Feig-Sandoval detests.

Binkley stated that for over a decade prior to his January 1997 response to Feig-Sandoval's article, the L5PBA had paid off-duty police officers to patrol the area and either arrest street drunks or pour out their alcohol. However, according to Binkley, this never solved the problem, but rather increased the amount of panhandling. Despite being arrested numerous times, he said, the street drunks always returned to L5P just to drink again. Binkley believed that the reason for this cycle of public drunkenness to jail and back to public drunkenness was the availability of cheap booze and suppliers of cheap booze who were willing to sell to customers who were clearly inebriated— namely, the aforementioned Chevron, where Binkley personally viewed numerous, well-known street drunks who staggered across Euclid to the Chevron and returned with booze. He believed that the Chevron owed it to the community to use discretion when selling alcohol, and that until that happened, there would always be these problems.[86]

Feig-Sandoval and Ginger Lyon, a twenty-year Inman Park resident at the time, were not just facilitating discourse; they became very active in the L5P community. I had lunch with Lyon, who explained to me that she "heard about something called the Partnership for Little Five Points and kind of fell into it. I inherited it."[87] The partnership was composed of representatives from Inman Park, Candler Park and the L5PBA and, for a period of time, held monthly meetings. Feig-Sandoval and Lyon co-chaired the partnership and worked hard to create Family Friendly Fun on Friday in Little Five Points, a monthly party aimed at healing divisions within L5P, as well as attracting people who normally would not visit the area. Besides showcasing Feig-Sandoval's fondness for alliteration, the party featured kite-making, live music and chess matches, as well as discussion on possible additions to the

neighborhood—like more trash cans and increased lighting—that would increase safety and cleanliness but not take away from the laid-back vibe of L5P. Binkley attended the event and praised it, saying, "For my part I'm glad that Inman Park and Candler Park neighbors will start to spend more time here and hopefully begin to understand more of what Little Five Points is about. And then together, we can work to deal with some of its problems."[88] The festival continued on the first Friday of every month for the next two years and helped continue discourse on ways to improve L5P.

Store owners and property owners also suffered from the homeless issue. As property taxes, as well as potential customers, increased in the area, so did the concern with panhandlers harassing and scaring off these potential customers. Even the ultra-liberal grocery store Sevananda placed signs by its checkout counters urging customers not to oblige panhandlers after one of them threw a rock at a customer. The sign read: "Please do not encourage this danger by giving away product or money to anyone near Sevananda's doors."

The *Atlanta Journal-Constitution* took notice of the gentrification of L5P in 1994. Staff writer Bo Emerson wrote about the change in revenue and rent occurring in the area in an article appropriately titled "The Greening of Little Five Points." Emerson examines the area's transformation: "Long stereotyped as a hippie haven, this once-scruffy nexus of head shops and anarchist politics is steadily becoming a high-cotton shopping district, where suburbanites browse $500 Finsters and $150 Doc Martens boots."[89] Take Sevananda, for example. Just a small neighborhood grocery store when it opened in 1974, Sevananda was doing nearly $4 million in business a year by 1994. The Junkman's Daughter was about to more than double in size, up to ten thousand square feet. The Euclid Avenue Yacht Club had doubled in size just a year earlier. As a result of L5P's success, property value in the area skyrocketed and, in turn, so did rent. When Pam Majors moved the Junkman's Daughter into the neighborhood in 1984, she paid $800 a month in rent. In 1994, the rent was $3,200 a month, quadruple the amount that she had originally paid.

Don Bender was outspoken in his frustration with the conditions in L5P. Not coincidentally, during the late nineties when the debate about the homeless was raging, apartments and condos were springing up faster than kudzu. As a result, the high-income residents who were tired of commuting from the suburbs moved in and caught L5P business owners' eyes. The Inman Park School and Inman Park Motor Works buildings were converted into condos, ranging from $130,000 to $160,000. However, the most eye-catching new residential development to L5P business owners was the new Bass Lofts.

Winter Properties bought the old Bass High School building (across the street from the Variety Playhouse on Euclid Avenue and right in the midst of L5P's commercial district) for $1.1 million in 1994—and transformed it into 133 loft apartments, which rented for up to $1,600 a month in 1998.

William A. Bass was one of Boys High School's most popular teachers in the early 1920s. After he passed away, his legacy was preserved when the new junior high school in L5P was named in his honor. One of Atlanta's first junior high schools, Bass Junior High opened in 1923 at 100 Euclid Avenue. It remained a junior high until 1948, when it was turned into a high school. A free-standing red brick gymnasium was added a year later.[90] By the early 1980s, Bass High School's enrollment was plummeting. In the 1983–84 school year, the high school, which was built to accommodate over 1,000 students, had only about 500 students. The next year, enrollment dropped to 425. By the 1985–86 school year, only 357 students attended Bass High, giving it the smallest enrollment in the city. The school had run its course and was closed after losing too many students to private and magnet schools.

In 1991, Rich's Academy, an alternative school for potential high school dropouts, joined Central Academy—a similar school—in the Bass High School building. The two schools had a combined enrollment of about two hundred students. Project Open Hand/Atlanta used the Bass High School cafeteria to serve lunch and dinner seven days a week in 1992. About five hundred people living within I-285 and suffering from HIV or AIDS were able to receive free meals from Open Hand volunteers. From 1994 to 1996, Mary Lin Elementary rented the building while its school building was undergoing renovations.

Bender, one of L5P's pioneer redevelopers in the 1970s, had admittedly gotten over "the more indulgent parts of the '60s where anything went."[91] After over two decades in L5P, he was quite fed up with potential business being scared off by rows of homeless people gathered on sidewalks, often making crude remarks toward females and aggressively panhandling. "Very few people want to put up with that kind of gauntlet," Bender told the *Atlanta Journal-Constitution* in June 1998. "This [the Bass Lofts] is a real opportunity for us. These are 130 to 260 new people living right on top of us who are a marketing opportunity. If people see them coming here to the higher-quality businesses, then more people would open those kinds of businesses rather than another thing that pierces body parts." As far as the homeless go, Bender said that many merchants continued to work with the American Civil Liberties Union. "We are keeping up the conversation, but we are business people and have to run our businesses."[92]

Jenkins took this picture of a homeless man with his dog. The man's dog was taken away shortly thereafter, so Jenkins made a number of reprints and gave them to him. *Courtesy of Reid Jenkins (www.freejoye.com).*

Bender explained to me, eleven years after the article was published, how he often took a personal interest in the homeless. However, he still views panhandling as a real issue in L5P.

I believe in civil liberties, but I also believe in the right not to be hassled. The question is how to balance the two. I worked on this question by becoming very individually involved with some of the homeless people. I hired them as I had things to do—didn't "pretend" hire them. I hired several homeless folks and some of them didn't work out too well. They were doing cleaning that had to be done every day; but if they were drunk it didn't get done. Even now we've been working with a person who does much of the cleaning in Little Five Points. And, every now and then, he gets drunk and winds up in jail. We work with him. I've set him up with a house to live in so he doesn't have to sleep outside.[93]

According to Shapiro, the majority of people who own businesses in L5P and are legitimately involved in the business community are sick and tired of the homeless distraction. I asked him whether he thought the homeless and runaway presence in the area helped to give it the unique flavor that draws in so many people. "I think they're a distraction," Shapiro quickly responded. "If people want to drive through the zoo and look at the stuff, I don't think that helps us."

"It used to drive me crazy," he told me. "We'd be at the business association meetings and some of the people who ran businesses knew the homeless guys who were sitting out on the plantings harassing their customers better than they knew their own customers."

There does not appear to be an answer to the homeless question. Some may feel that treatment is the best option for the homeless in Little Five, yet as Bender explained to me, the majority of the homeless don't want treatment. Many like living on the streets, especially the young runaways whose youth, I believe, is beneficial. Young, wandering folks with faces void of the years of hard living shown in their adult counterparts seem to thrive in Findley Plaza. Standing alone or in groups with guitars and bongos singing Grateful Dead songs off key, these young nomads appear much more attractive to the "socially conscious" pedestrians than the brooding, smelly old man sitting outside Sevananda with his head in his hands. Yet even he can muster up enough cash to head over to the liquor store a couple of times per day. If the police were to crack down on the panhandlers and force them out of L5P, then they would become someone else's problem. Personally, I enjoy seeing

A young woman smiles for a picture in Findley Plaza. Part of street journalism, according to Ebrima Ba, is using pictures as a vehicle for telling a story. I met Ebrima Ba on Euclid Avenue, where he was selling his pictures. *Photo by Ebrima Ba.*

A wandering couple walks up Euclid Avenue. They are living out of their backpacks in Findley Plaza. *Photo by Ebrima Ba.*

Ebrima Ba took this picture because he often saw joy in this man's face despite the fact that the man had almost no material possessions. *Photo by Ebrima Ba.*

the vagabond crowds that congregate in Findley Plaza and sing off-key Dead songs. I also enjoy watching middle-class families stop and listen and maybe put a buck or two in the performer's hat. Far from being a circus act, I think it reminds folks that even though L5P is now a much safer place for all, there is still a visible counterculture. Not a pseudo-counterculture as seen in other parts of the city, but a true cultural and socioeconomic melting pot that can only be found in Little Five Points. This is an essential part of L5P's mystique. As Harry DeMille told me, "I see a lot more kids from suburbia coming in on the weekends to see Little Five Points. They don't come to see me, or any one thing; they come to see *the* Little Five Points."

I was not able to interview any of the officers from the mini-precinct because of procedural issues, but I have an idea of how they approach the homeless issue. Since the officers have a fairly small area to cover and the homeless are out every day, the police become familiar with them and know which ones are peaceful and which ones are aggressive. This makes it easier for them to keep an eye on potential troublemakers. Granted, this is not a perfect system, but it beats pawning down-on-their-luck panhandlers and drifters off on another, less tolerant, neighborhood.

STAYING INDEPENDENT IN THE CORPORATE WORLD

O ne of the things that Jordan wanted to ensure as he helped revitalize L5P was that people could take care of their basic needs in the commercial district. As a result, it was necessary that a pharmacy be established. (In the old days, L5P had several pharmacies.) Not surprisingly, it was difficult to find someone qualified who was willing to take the risk of opening a pharmacy in the still reemerging area. Jordan kept trying, persistent as ever, and eventually found his man.

Despite his friends' warnings, Ira Katz opened the Little Five Points Pharmacy in 1981. Little Five was still a redeveloping area, even though stores like Wax n Facts, Stefan's Vintage Clothing and Charis Books had opened and given the neighborhood some stability. Katz saw potential in the neighborhood and, after working for a chain pharmacy for two years, decided that it was time to go into business for himself. He explained his plan to me:

> *I went to the director of the Georgia Pharmacy Association and told him, if he ever heard of anyone looking to sell a pharmacy or looking to build a pharmacy, I'd be interested; so I went outside the perimeter, to Duluth, to Alpharetta, and it was virgin territory then but you could see that in the future there would be a chain on every corner. Fortunately, Kelly Jordan got in touch with me and I remember meeting him at the Little Five Points Pub in early 1979 and looking over all the plans that he and Don Bender had for the area. We talked for over three hours and I came*

Mayor Jackson congratulates Ira Katz on the opening of the L5P Pharmacy. *Courtesy of Kelly Jordan.*

home, woke up my wife and said, "I think I've found where I want to put the pharmacy." [94]

Katz moved into the 484 Moreland Avenue building, newly developed by Jordan and designed around Katz's pharmacy. During his first couple of years in business, Katz developed a successful business formula that the two other neighboring pharmacies could not compete with. He offered free delivery, longer hours and 365-day-a-year service. Katz won with grass-roots democracy, not with backhanded maneuvering or by undercutting prices, and he soon developed a loyal customer base within the community.

Over a decade later, the Little Five Points Pharmacy faced what is every independently run business's nightmare—a big business takeover of the industry. In 1993, corporate giant Revco Pharmacy announced plans to open a new store next door to the Little Five Points Pharmacy, where the Value Foods Grocery store had closed. A graduate of Emory University and St. John's University College of Pharmacy, Katz thought there was no chance of survival if a store like Revco, which can buy in bulk and undercut

prices, opened up next door. Unbeknownst to Katz, his greatest asset against Revco would be the clients whose business he feared losing.

Hundreds upon hundreds of phone calls and faxes flooded the Revco corporate headquarters, making it clear that the corporate giant was anything but welcome in Little Five Points. Billion-dollar corporations were sucking the lifeblood out of seemingly every section of America, but not in Little Five Points, cried protestors. "Revco had never seen anything like it," said Katz.[95] On November 6, 1993, over forty Little Five Points residents, armed with flyers that read "McHell McNo Revco," gathered to rally against corporate intrusion. One resident voiced her opinion to the crowd, proclaiming, "Don't let Revco get a foot in the door. If it does, pretty soon men will have short hair, women long hair and I'll have a Ross Perot bumper sticker on my Volvo. The next thing you know, we'll all be voting Republican." Another resident said of Katz: "Ira does the extra things corner drugstores used to do for people. He and his staff know you by name and they treat you really well. You're not just another walking wallet."

I spent about thirty minutes interviewing Katz at the Little Five Points Pharmacy and got to see firsthand how he interacts with his customers. When a customer walks in, Katz smiles and walks over to his cart with recently filled prescriptions. He does not need to look in a computer database; he knows every patient and what medicine(s) they take. He shows what appears to be a genuine interest in them. Katz will ask them questions about their lives, and a discourse will ensue that is more friend to friend than pharmacist to patient. Never once was I skeptical of his sincerity. Every transaction that went on during the interview was refreshing to me. There is a level of personal care that is uncommon at chain pharmacies.

In response to the protests, vice-president of communications for Revco Bob Newmark made a feeble attempt to give the corporate giant a "neighborly" feel. "Revco is a community pharmacy," Newmark said. "We employ local people. This [opposition] is very strange."[96] By December 1993, Katz and his supporters were planning a "David Beat Goliath" party. At the same time, Revco was placing calls to Value Foods Grocery, the fifteen-thousand-square-foot site that it wanted to occupy, to say that the company was no longer planning to move in. Little Five Points resident and Revco protestor Dick Bathrick said it best: "We stated clearly that we would not patronize their store if Revco came in. I think they decided it's not worth the trouble. We like a sense of community control over the businesses that serve us. We're not interested in having corporate national chains."[97]

Starbucks first showed interest in Little Five Points in 1995 during its initial quest for world dominance. The corporation approached Aldo Hartz, then owner of the Hartz Building next to the old Texaco on Moreland Avenue, about leasing space in his building. According to Hartz, Starbucks offered him a good deal and planned improvements for the building, which he liked. However, Hartz claims that when one of Starbuck's real estate representatives came down for a visit, his car was "spray painted or something," causing him to change his mind about the area. In 1996, the Herculean chain made another attempt at infiltrating the neighborhood when it contacted Bob Sharpe, owner of the old Texaco directly across the street from what likely would be another casualty of Starbuck's quest for java oligopoly—Aurora Coffee. Ultimately, the deal fell through when the two parties failed to agree on a price.[98]

Yet it was only a matter of time. By the turn of the millennium, there was a Starbucks on every corner, and the intersection of Moreland and Seminole was no exception. Starbucks eventually opened in late September 1999, on a lot that was previously home to a Volkswagen repair shop. The old VW shop was in keeping with the counterculture vibe of Little Five—its lot was filled with dozens of old VW buses and Bugs, worn down from years on America's highways. What Starbucks brought with it was the antithesis of the VW shop—corporate America. It was the end of the millennium and, in some Little Five residents' eyes, the beginning of a corporate takeover. However, despite Starbucks' arrival, Little Five's favorite coffee destination, Aurora Coffee, continued to thrive, with lines of customers reaching from the counter out the door. Starbucks and Aurora did share one honor in *Creative Loafing*'s Real-End-of-a-Millennium Awards: the prestigious "You'll Never Go Broke Selling Drugs in L5P Award"!

Starbucks has managed to turn a profit without really disrupting the flow of business for Aurora and newer coffee joints like L5P Business Association president Rob Thompson's Java Lords. Apparently, there are enough loyal and passionate coffee drinkers in Little Five to make a monopoly on java unlikely.

On May 20, 2002, the *Atlanta Business Chronicle* announced that the Atlanta Gas Light Company (AGL), a subsidiary of AGL Resources Inc., had reached an agreement to sell its Caroline Street headquarters to Florida-based developer the Sembler Co. The AGL had operated at the Caroline Street campus, south of Little Five Points on Moreland, since 1959.

Sembler Co. beat out other big-name developers with a plan that originally called for over 720,000 square feet solely for retail.[99] Immediately

after plans were announced, L5P business owners like Eric Levin, owner of Criminal Records, began to speak out. "They're talking about a Best Buy or a Circuit City, and that is absolutely 100 percent devastating to a store like Criminal Records," Levin said.[100] The threat of a big-box shopping center right down the road was an affront to L5P on many levels. First, it totally undermines what L5P struggled so long to obtain: a pedestrian-friendly area with locally owned businesses. The first eight retailers to reserve space in the retail district were corporate giants: Lowe's Home Improvement, Target, Kroger, Barnes & Noble, Bed Bath & Beyond, Ross Dress for Less, Cost Plus World Market and Petsmart.[101] Second, a project this large is guaranteed to increase traffic, and therefore it must be reviewed by the Georgia Regional Transport Authority, which estimated that the development would result in an increase of approximately twelve thousand car trips daily.

For Sembler and Co., everywhere it looked there were dollar signs. Leading the charge was Jeff Fuqua, president of development. He saw a gold mine full of upper-middle-class households with nowhere nearby to shop for their basic household needs. "There's no competition around it, and the population is four or five times higher in the trade area than our suburban projects," said Fuqua.[102] According to his numbers, there were nearly 131,000 people within a three-mile radius of the proposed development site, and their average household income was $63,234. Stretch it out to five miles from the development and you have 322,000 people with an average household income of $59,070.[103]

Some residents of Inman Park were vehemently opposed to the development and harked back to the 1980s, when they fought off the Department of Transportation from extending the Presidential Parkway through the neighborhood. However, Inman Park is located within Neighborhood Planning Unit N (NPU-N), and the proposed development site was located within NPU-O, which represents the Edgewood community. City hall would take Inman Park's concerns into consideration, but ultimately the NPU-O had the final say in the matter. Inman Park had legitimate concerns, Shapiro explained:

Moreland Avenue has to be four lanes since it goes under the bridge and DeKalb Avenue is sort of a weird cross street that people don't know how to utilize. So, basically all of that traffic has to dump onto four lanes of Moreland. Here everybody's going to have to filter through the residential streets…the size and location of that thing always bothered me. It's too much in the middle of several residential neighborhoods. If it had been at

*the intersection of Moreland and Memorial, that would be great. You've got
lots of cross streets, you've got I-20 and it's a light industrial neighborhood.
But to put a giant, suburban shopping center in the middle of a residential
area just doesn't make sense.*[104]

If Inman Park wanted to get involved with Edgewood in order to steer
it toward opposing the development, its hopes were stomped out after a
quote from an Inman Park representative in the *Atlanta Journal-Constitution*
infuriated Edgewood's neighborhood leadership. When asked about the
proposed development, the resident exclaimed: "We're just not going to
let it happen. Inman Park decided to stay quiet and let Edgewood handle
negotiations to this point. We're richer in resources and money and talent
in general [but] we didn't want to force ourselves on the process."[105] NPU-
O chairperson Shawnalea Garvin-Campbell fired back, saying: "I think
that's ridiculous. There are seven architects in our neighborhood. We have
commercial designers and real estate people…we have all the talent we need.
Thanks, but no thanks."[106]

The division between the two neighborhoods was clear as day. Inman
Park residents hated the idea of a big-box retail area moving down the
street from L5P—the area they had worked on so hard to turn into what
it is today. Not to mention the traffic congestion the development would
create. The Edgewood community, a more blue-collar district, was thrilled
about the prospect of some 1,600 new jobs being created with the shopping
center's arrival, jobs that Sembler Co. said would put money directly into
the community. One of the many compromises that Sembler Co. made with
various community representatives was a guarantee that 120 residential
units would opened along with the retail district. An eventual 300 affordable
residential units were promised, including 135 specifically for the elderly.
Edgewood's city councilwoman, Natalyn Mosby Archibong, was convinced
that the development would indeed enrich the community. "The prospect
of having 1,600 jobs is very important. To have these jobs where people can
use mass transit to get to them is important. There's a doubling of affordable
housing in this development, considering the units for seniors. I am in favor
of the development."[107] So was the rest of Edgewood, and the project quickly
cut through all the red tape that stood in its way.

When it opened in 2005, the Edgewood Retail District (ERD) looked
fairly different from the way that Sembler had originally envisioned it. The
720,000-square-foot development was scaled down to 536,604 square feet.
Sembler made other compromises, like providing $100,000 to Inman and

Candler Park for traffic-calming measures. It provided funds for a new traffic light at the intersection of Moreland Avenue and Hardee Street and for a shuttle to run to and from nearby MARTA stations. Some beautification efforts were also made, such as lining the main boulevard through the district with flowers and benches. Also, a two-story wall was created along the sidewalk on Moreland Avenue to make the development better fit in with a pseudo-neighborhood feel.

These were nice concessions, but they did little to alleviate the flood of traffic through L5P that the retail district created. Parking in the shopping center is mediocre at best—the stores are spread far apart, and parking spaces are scattered throughout. Rather than building a parking garage at the back of the complex and lining the stores up next to one another so that shoppers could walk along a sidewalk from one store to another, Sembler built strips of parking, connected by narrow lanes over 500,000-plus square feet. Patrons have to get in their cars and drive or weave their way on foot or bicycle through hundreds of cars if they want to go from one store to another. This causes constant traffic congestion within the complex. The place is poorly designed, and it contradicts the idea of a neighborhood commercial district like Little Five Points. In fact, it is the antithesis of Little Five Points, which is made up of small, locally owned stores lined along the sidewalk and perfect for pedestrian traffic. The Edgewood Retail District is a giant cluster of corporate chains awkwardly spread out in a pedestrian's nightmare.

"I felt very betrayed by the city," Shapiro said to me. "They told us the Neighborhood Commercial District is a great idea—keep everything local—and then they open the mega suburban-style shopping center right down the road—literally on the border of the city's first Neighborhood Commercial District. It's very ironic."

The Edgewood Retail District is still a sore spot for many Little Five faithful. Yes, it is a traffic problem and has stolen some business from L5P, but it is not right next door to L5P. In fact, the cluster of corporations is not even visible from any point in Little Five. Also, all of the store owners whom I interviewed said basically the same thing that Crystal Blue co-owner Brett Vaillancourt told me: "It [the Edgewood Retail District] doesn't bother me because none of the stores down there sell what we sell here."[108] The majority of L5P shops are so unique and original that their products are not mass produced like products found in a corporate chain store, and consequently, the stores in the ERD are not much of a threat to steal customers. In fact, many of the shops in L5P have patrons who drive in from all over the Southeast because the shops specialize in such rare products.

Starbucks broke through the invisible, anti-corporate wall into Little Five Points but is still somewhat on the outskirts looking in. Though Starbucks is technically in the boundaries of Little Five, it is in a small section at the corner of Moreland and Mansfield. Not until March 2006 did American Apparel move smack-dab into the middle of Little Five Points' main strip on Euclid Avenue. That's right, an LA-based national clothing chain opened up in an area that once seemed untouchable by corporate America. The store offers clothing similar to stores like the Clothing Warehouse and Rag-O-Rama at a decidedly higher price. Yet in 2006, some local store owners argued that American Apparel was just what the doctor ordered. One such store owner was Jilene Coggins, owner of Envy boutique on Euclid, who liked the idea of American Apparel moving in because "it's got a lot of advertising dollars to spend, and that will help bring up the business for all of us."[109]

It is true that the locally owned stores in Little Five often can't compete with mainstream shopping districts like Atlantic Station and Midtown, and therefore American Apparel could bring in customers who otherwise would not have known about Little Five. Yet walking into American Apparel does not have the same feel as the mom and pop stores that are the fabric of the area. American Apparel is lined with racks of trendy clothes hung by trendy employees. The store even smells trendy, if that's possible. This is not to say that other Little Five establishments are not "trendy," since Little Five is no longer just a place for those on society's fringe and has veered more toward the mainstream.

Another victory that Shapiro scored during his presidency ensured that big business would find it very difficult and even unappealing to move into L5P. In 2001, L5P became Atlanta's first Neighborhood Commercial District (NCD). The Atlanta City Council created this new zoning designation on September 18, 2000, in order to limit the shape and size of new development. Shapiro fought for L5P to become an NCD and added another stipulation to the designation as it applied to L5P: that no more than 25 percent of businesses within L5P can be restaurants or bars. Shapiro added the stipulation after planning studies showed that when over 25 percent of businesses in small commercial nodes are restaurants and bars, "it starts spiraling and more and more restaurants open and it becomes less of a place for local folks to come shop and turns into more of a regional shopping area."

Equally important, the NCD designation limits the shape and size of new businesses and keeps the area pedestrian friendly, therefore protecting the environment already in place. Buildings have to be built by the street, and

The Vortex is one of L5P's most popular restaurants, and I could not resist including a picture of its façade. *Courtesy of Robert Hartle Sr.*

if they want their own parking area, it must be behind the store, not in the front. Basically, new businesses have to stay within the parameters that are already in place, meaning that if the GAP wanted to buy up a vacant lot and build a new store, it would be out of luck.

It is impossible to overstate the importance of L5P having the NCD designation. With it in place, L5P becomes not only a difficult area for big business to infiltrate but an unappealing area as well; the concessions that big business would have to make would not be worth the trouble. Big-box stores are immediately ruled out. There are no lots big enough for a Sam's Club or a Target to move into, and the only store large enough to accommodate a chain store like the GAP is the Junkman's Daughter. The Junkman's Daughter is probably not going anywhere anytime soon, and even if it were to close or relocate, corporate chains have faced enough opposition trying to locate in L5P in the past that none would be likely to take the risk.

Lots of anti-corporate folks despise Starbucks for being on every corner of every street everywhere, but Starbucks generally treats its employees well, providing them with excellent benefits. I may not shop at American Apparel, but it does sell only American-made clothing, and some people find that refreshing. I just do not think corporations have a place in Little Five. The remarkable thing about L5P is the individual expression manifested in small,

independently owned shops that sell the most diverse range of goods found anywhere. The pedestrian atmosphere adds to the independent spirit as well as to the cultural, racial and socioeconomic mix. It is like an outdoor art gallery with shop windows through which pedestrians marvel at the array of crystals at Crystal Blue or the African masks at the L5P Bazaar. It appears that the independently owned shops in L5P are safe, thanks in large part to Shapiro's dedication to preserving L5P's atmosphere through its designation as a Neighborhood Commercial District.

NOTES

Chapter 1

1. Doris Kearns Goodwin, *Team of Rivals: The Political Genius of Abraham Lincoln* (New York: Simon & Schuster, 2005).
2. John W. Brunsfield, "Losing the Battle of Atlanta: First the Fight, Then the Battlefield. Atlanta Is About to Bury One of Its Most Sacred Spaces under a Retail Development," *Atlanta Journal-Constitution*, July 18, 2004.
3. Ibid.
4. *Atlanta Constitution*, "Moreland Park," July 18, 1886.
5. Ibid.
6. *Atlanta Constitution*, "Moreland School Opens This Week," October 6, 1913.
7. *Atlanta Constitution*, "To Lay Cornerstone of Moreland School," September 21, 1918.
8. *Atlanta Constitution*, "New Commercial Block for Inman Park," March 5, 1922.
9. *Atlanta Constitution*, "Edgewood Property for Sale," September 12, 1871.
10. *Atlanta Constitution*, "Turning Renters into Home Owners Now the Work of Real Estate Men," February 21, 1909.
11. *Atlanta Constitution*, "The Constitution's Real Estate Review," September 30, 1923.
12. *Atlanta Constitution*, "Display-AD 9," September 29, 1923.
13. *Atlanta Constitution*, "Two Officers Face Liquor Charges Today," September 5, 1924.

14. *Atlanta Constitution*, June 20, 1936.

15. *Atlanta Constitution*, "Cornerstone Will Be Laid," March 17, 1898.

16. *Atlanta Constitution*, "Epiphany Entertainment," June 15, 1920.

17. *Atlanta Constitution*, "Bishop Mikell Opens Episcopal Mission," July 15, 1923.

18. *Atlanta Constitution*, "Churches and Church News," May 26, 1895.

19. *Atlanta Constitution*, "You Shut Up! Exclaims Pastor," January 6, 1911.

20. *Atlanta Constitution*, "Church Buys a New Home," November 20, 1932.

21. Kevin Duffy, "Church Condo Plan Likely to Pass," *Atlanta Journal-Constitution*, August 7, 2008.

22. *Atlanta Constitution*, "Palace Theatre," January 4, 1925.

23. *Atlanta Constitution*, "Little Five Points Civic Association Organized to Upbuild Community," November 23, 1937.

24. http://www.inmanpark.org/l5p.html.

25. Patricia Sprinkle, "Road Rage," *Atlanta Magazine*, October 2005.

26. Kevin Kruse, talk given at Emory University, November 3, 2005.

27. John Sweet, interview with the author, December 2009.

28. *Great Speckled Bird*, "Stone Mountain Tollway—The Land Use Question," January 9, 1973.

Chapter 2

29. Don Bender, interview with the author, October 2009.

30. Kelly Jordan, interview with the author, October 2009.

31. "The B.O.N.D. Community Plan," 5.

32. Sweet interview.

33. www.bondcu.com/site/bond/AboutBONDCFU.asp.

34. Ibid.

35. Sweet interview.

36. *Community Star*, "Credit Union Open Every Day," September 1976, vol. 6, no. 6.

37. Peter Mantius, "Freeway Battles Have Helped Form Economic Bond in Little Five Points," *Atlanta Journal-Constitution*, May 19, 1985.

38. *Community Star*, "Little Five Points Business District Revitalization Plan," December 1976, vol. 6, no. 9.

39. Jordan interview.

40. John Sugg, "Atlanta's Chief Angel," *Creative Loafing*, January 29, 2003.

41. Bender interview.

42. Jordan interview.

Chapter 3

43. *Southway Theatres, Inc. Plaintiff-Appellant v. Georgia Theatre Company, et al, Defendants Appellees.* United States Court of Appeals, Fifth Circuit. Westlaw. No.80-7672.

44. *Atlanta Constitution*, "Euclid Film House Will Open Today," October 4, 1940.

45. Eleanor Ringel, "Movie House in Age of Multiplexes, Ellis Was the Real Thing," *Atlanta Journal-Constitution*, August 14, 1988.

46. Actor Cordell, "Live Shows Planned at Ellis Cinema: Producer to Reopen Theater With Old Stars," *Atlanta Journal-Constitution*, June 8, 1989.

47. *Atlanta Constitution*, "Little 5 Points Theater to Be Opened Today," September 21, 1940.

48. http://www.7stages.org/cgi-bin/MySQLdb?FILE=/about/index.html.

49. Paula Crouch, "'Mr. Universe' Leads Off-season of New Plays at Seven Stages," *Atlanta Journal-Constitution*, July 31, 1987.

50. http://www.7stages.org/cgi-bin/MySQLdb?FILE=/about/index.html.

Chapter 4

51. Harry DeMille, interview with the author, September 2009.

52. Rebecca Birdwhistell, interview with the author, September 2009.

53. H.M. Cauley, "Feminist Bookstore Preserves. Charis Books Marks 35 Years: Diversity of Titles Helps Independent Shop Find Success," *Atlanta Journal-Constitution*, October 25, 2009.

54. Ibid.

55. H.M. Cauley, "Bookstore Fights to Stay Open," *Atlanta Journal-Constitution*, December 22, 2005.

56. http://microformguides.gale.com/Data/Introductions/33130FM.htm.

57. Judy Hotchkiss, "Song Remains the Same for Sevananda: Only Healthy Foods—and No Red Meat," *Atlanta Journal-Constitution*, October 14, 1993.

58. http://www.sevananda.coop/retailer/store_templates/ret_about_us.asp.

59. Lessie Scurry, "Market Shares Health, Profit with Community," *Atlanta Journal-Constitution*, November 28, 2002.

Chapter 5

60. Harlon Joye, interview with the author, September 2009.
61. Heather Gray, "WRFG's History in Progress: An Interview with Harlon Joye," July 1993.
62. Ibid.
63. Robert Pear, "Behind the Prison Riots: Precautions Not Taken," *New York Times*, December 6, 1987.
64. Scott Henry, "Prison Riot!" *Creative Loafing*, November 21, 2007.
65. Amy Wallace, "Detainees Report FBI Threats to Revoke Paroles," *Atlanta Journal-Constitution*, December 15, 1987.
66. Kay Powell, "Obituaries: Stone Mountain. Ebon Dooley, 'Political Guide' at Nonprofit Radio Free Georgia," *Atlanta Journal-Constitution*, October 17, 2006.
67. Holly Crenshaw, "Obituaries: Atlanta. Robert 'Joe' Shifalo, Musician, 'Mayor' of Little Five Points," *Atlanta Journal-Constitution*, March 29, 2009.
68. http://www.atlantaprogressivenews.com/news/0052.html.

Chapter 6

69. Dan Baum, "Skinheads Get in Merchants' Hair: Little Five Points Becomes Hangout for Tattooed Group: *Atlanta Journal-Constitution*, May 14, 1986.
70. Nehl Horton, "Skinhead Violence Protested," *Atlanta Journal-Constitution*, June 26, 1986.
71. Dan Baum, "Reaction to Klan Gathering Called Reassuring," *Atlanta Journal-Constitution*, June 16, 1986.
72. Sandra McIntosh, "Young Woman Shot Dead Near Little Five Points," *Atlanta Journal-Constitution*, August 24, 1988.
73. David Penly, "Shoot-Out Kills Officer, Suspect in Lake-Claire: Gunman on Bicycle Fits Description of Man Sought in Little 5 Points Killing," *Atlanta Journal-Constitution*, August 26, 1988.
74. Adam Gleb, "Police Officer Who Was Slain Counseled Those He Arrested but Lake Claire Cyclist Didn't Give Him a Chance," *Atlanta Journal-Constitution*, August 27, 1988.
75. Adam Gleb, "Slain Officer Gave Life for Others, Mourners Are Told," *Atlanta Journal-Constitution*, August 31, 1988.
76. Gleb, "Police Officer Who Was Slain."

77. Richard Shapiro, interview with the author, September 2009.

78. Ginger Lyon, interview with the author, September 2009.

79. *Atlanta Journal-Constitution*, "Around Intown: Officer Cook Gets Davis Award," July 6, 1989.

80. Denise N. Maloof, "Keeping the 'Mystique': Neighbors Unite after Little Five Points Shooting," *Atlanta Journal and Constitution*, August 31, 1995.

81. Kathy Scruggs, "Bubble Gum Gang Called Attack Target," *Atlanta Journal-Constitution*, July 25, 1995.

82. Maloof, "Keeping the 'Mystique.'"

83. Lyda Longa, "Tot Kidnapped at Restaurant: Detectives Search for Clues to Disappearance at Little Five Points," *Atlanta Journal-Constitution*, April 11, 1998.

84. Shapiro interview.

85. Steve Visser, "Attacker Found Guilty of Hate Crime," *Atlanta Journal-Constitution*, October 22, 2003.

86. "An Open Letter to Lori Feig-Sandoval," *Inman Park Advocator*, January, 1997.

87. Lyon interview.

88. Holly Crenshaw, "More than Fun and Games: Festival Aimed at Helping Heal Neighborhood Divisions," *Atlanta Journal-Constitution*, April 10, 1997.

89. Bo Emerson, "The Greening of Little Five Points: The In-crowd Is Expanding to the Funky Side of Town as Flocks of Folks Try to Cash in on Bohemian Capitalism," *Atlanta Journal-Constitution*, May 22, 1994.

90. *Atlanta Journal-Constitution*, "Q&A on the News," June 20, 2008.

91. Melissa Turner, "Changing Bohemia: Little Five Points, a Haven of Counterculture Faces Gentrification and Dissension," *Atlanta Journal-Constitution*, June 29, 1998.

92. Ibid.

93. Bender interview.

Chapter 7

94. Ira Katz, interview with the author, September 2009.

95. Stephanie Sonnenfeld, "Staying Independent in a World of Chains," *Atlanta Business Chronicle*, January 2, 1998.

96. Richard Bono, "Little Five Points: Corporate Giant Not Welcome," *Atlanta Journal-Constitution*, November 11, 1993.

97. Richard Bono, "Little Five Points Plans Victory Celebration but Revco Won't Claim Defeat," *Atlanta Journal-Constitution*, December 30, 1993.

98. Tinah Saunders, "No Starbucks Deal a Perk in Little Five Points," *Atlanta Journal-Constitution*, February 27, 1997.

99. Jared Schenke, "Massive Shopping Center Planned for AGL Site," *Atlanta Business Chronicle*, July 12, 2002.

100. Milo Ippolito, "Neighbors Have Reservations about Intown Retail Center," *Atlanta Journal-Constitution*, September 12, 2002.

101. Renee DeGross, "Key Retailers Like Moreland: Eight Sign on for Edgewood Project," *Atlanta Journal-Constitution*, May 3, 2003.

102. *Atlanta Journal-Constitution*, "Our Opinions: Edgewood Plan Worth Pursuing," April 25, 2003.

103. DeGross, "Key Retailers Like Moreland."

104. Shapiro interview.

105. David Pendered, "Inman Park Vows to Fight Edgewood Mixed Use Plan," *Atlanta Journal-Constitution*, April 3, 2003.

106. Ibid.

107. David Pendered, "Atlanta Council to Rule on Plan: Sembler Proposal Likely to Get OK," *Atlanta Journal-Constitution*, April 21, 2003.

108. Brett Vaillancourt, interview with the author, September 2009.

109. Christine Van Dusen, "A Blow to Independence: Some in Little Five Points Don't Like the Thought of a Chain, Even a Quirky One," *Atlanta Journal-Constitution*, February 1, 2006.

ABOUT THE AUTHOR

Robert Hartle Jr. has lived in Atlanta, Georgia, since 1984. He studied history at the University of Dallas in Irving, Texas, before moving back to Atlanta. After discovering his love for history and writing in college, Hartle worked as a research assistant on Emory University professor of law Polly Price's book, *Judge Richard S. Arnold: A Legacy of Justice on the Federal Bench*, before writing his first book, *Atlanta's Druid Hills: A Brief History*. This is Hartle's second book with The History Press.

Courtesy of Robert Hartle Sr.

Visit us at
www.historypress.net